300% Cotton

Cotton

More T-Shirt Graphics

Published in 2006 by
Laurence King Publishing
email: enquiries@laurenceking.co.uk
www.laurenceking.co.uk

Copyright © 2006
Laurence King Publishing

A catalogue record for this book is
available from the British Library.

ISBN 13: 978-1-85669-491-9
ISBN 10: 1-85669-491-7

Words: Helen Walters

Book design and cover illustration:
FL@33
www.flat33.com

Senior editor: Catherine Hall
Assistant editor: Andy Prince

Printed in China

300% Cotton

More T-Shirt Graphics

Words: Helen Walters

Book design and cover illustration: FL@33

Laurence King Publishing

Contents

Intro

There's an apparently limitless supply of artists experimenting with emblazoning their images onto cotton. This book celebrates those who are exploiting the medium to the full, using the shirt as a means of showing off their own artistry and creativity.

Many of those featured here don't just design T-shirts. What's been particularly noteworthy in the years since 200% Cotton was published (this is the third book in the series) is that while graphic designers, illustrators and the like continue to experiment with the medium, fashion designers have begun to reclaim their own. For too long, the T-shirt was considered the poor relation of 'real' fashion. A number of years ago, Karl Lagerfeld notoriously dismissed Stella McCartney as 'that T-shirt designer', a term that in his eyes obviously provided the ultimate insult.

That's not to say that many couture fashion designers don't see the lucrative possibilities of sticking their logo on a T-shirt and flogging it for a fortune. But now, more and more young, up-and-coming fashion designers are thinking about the form and what it can do for them, as well as for what their designs can do for it. Experimenting with fabrics, toying with graphic placement, people can – and do – print anything on a T-shirt, and it makes the field both fantastically vibrant and fascinating to observe. The exceptions, perhaps, are those oh-so-ironic slogans that are everywhere on the high street and have become a little tired and stale. (The ones of that ilk featured here are genuinely new takes on an existing logo or eye-catching graphics that are often humorous and always startling.)

A more concerning development has been the increasingly repressive official response to shirt images. These graphics have always been about confrontation, from the first punk shirts, with their sexually explicit and politically challenging imagery, to Katharine Hamnett famously confronting the British Prime Minister, Margaret Thatcher, with her bluntly put opinion on nuclear weapons. Clothing graphics are renowned for

Intro

allowing a wordless but powerful communication.

It's a sign of our times, however, that silent sentiment can now be enough to provoke an unnervingly strong-armed reaction. In October 2005, Lorrie Heasley was asked to leave a Southwest Airlines flight in Reno, Nevada, because she was wearing a T-shirt showing images of George Bush, Dick Cheney and Condoleezza Rice above the slogan 'Meet the Fuckers'. Having refused a request to turn her shirt inside out, Heasley was asked to disembark the plane. 'I just thought it was hilarious,' she said to reporters at the time. 'Here we are trying to free another country, and I have to get off an airplane—over a T-shirt. That's not freedom.'

Similarly, peace activist Cindy Sheehan was arrested on charges of 'unlawful conduct' before President Bush's State of the Union address in Washington DC on 1 February 2006. Her crime? Wearing a shirt on which was printed '2,245 Dead. How many more?' A reference to the number of US soldiers (including her son) killed in the Iraq War to that point, her protest was non-violent but nonetheless deemed aggressive enough to warrant her arrest. The authorities later apologized for their approach, but that's hardly the point: Bush got to avoid the issue and Sheehan's case was not made.

Optimists like to argue that culture is always moving forward. By its very nature, it has to evolve, but these intransigent, heavy-handed reactions highlight a potentially frightening future. If the puritanical and conservatives have their way, culture and society will not become freer and more open. Quite the opposite: freedom of speech will become as antiquated a concept as the mullet hair-do. While the idea that you could offend through the marks on your T-shirt was previously more the viewer's problem than the wearer's, this new reality is an affront that should strike fear into the hearts of all. Wearing a provocative T-shirt might seem like a small act of defiance, but at least it's something. These days, it should be mandatory to wear your heart on your sleeve. Or, at least, on your shirtfront.

Make

These artists are doing it for you. And themselves. Give an artist an outlet, already.

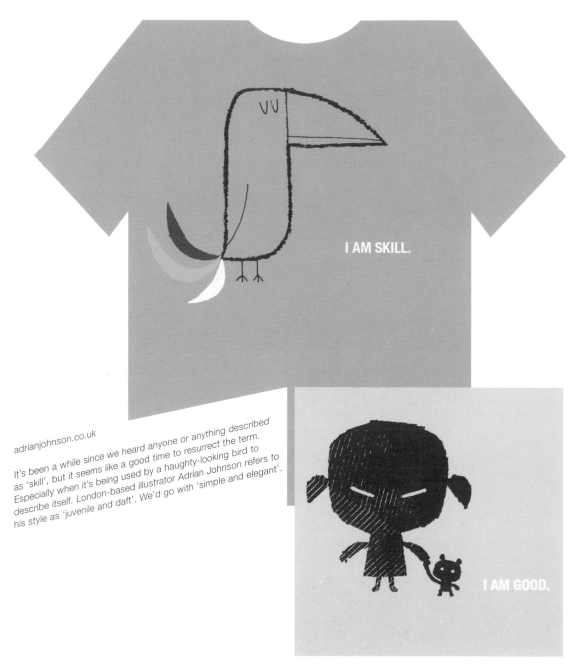

I AM SKILL.

I AM GOOD.

adrianjohnson.co.uk

It's been a while since we heard anyone or anything described as 'skill', but it seems like a good time to resurrect the term. Especially when it's being used by a haughty-looking bird to describe itself. London-based illustrator Adrian Johnson refers to his style as 'juvenile and daft'. We'd go with 'simple and elegant'.

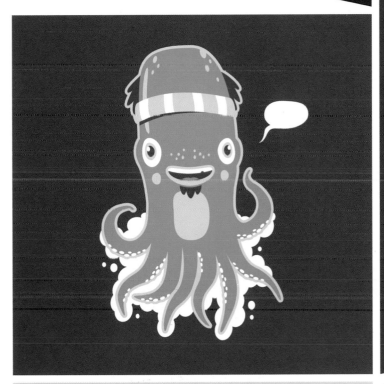

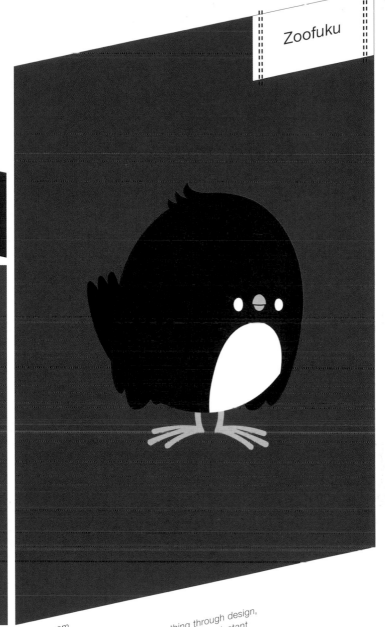

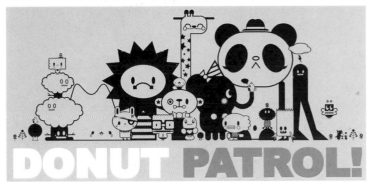

zoofuku.com

'T-shirt graphics give beauty to something through design, while they also provide an opportunity to gain an instant rapport with the beholder,' says Cheryl Chng of Singapore-based apparel design company Zoofuku. Their cute caricatures are created with a host of international collaborators, including Christian Lindemann, Dyrdee, Maki Maki and Tado.

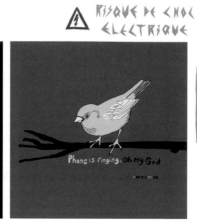

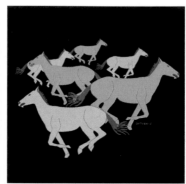

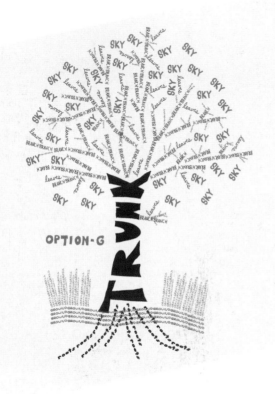

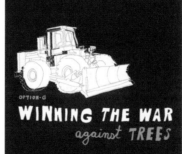

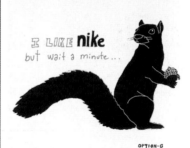

option-g.com

'I wear T-shirts 90% of the time, so having a T-shirt line was a natural progression from my other design and art,' says Cole Gerst of the Los Angeles–based company he founded in 2004. His humorous shirts often tout a hand-drawn aesthetic, while Gerst tries to steer clear of anything overly slapstick or preachy. 'A shirt doesn't have to have a message or be in your face,' he says. 'A good graphic could just present someone's vision of the world around them.'

imperfectarticles.com

The theory that everyone has a T-shirt graphic in them is neatly emphasized by the team behind this Chicago-based company. Co-founders Noah Singer and Mike Andrews commission painters, sculptors and creative types otherwise unconnected to the world of fashion to create original designs that they then screen print by hand onto hand-dyed shirts. Allowing the artists the freedom to create whatever they like, the results are eclectic, to say the least. Or, as Singer puts it, 'They're striking designs showing off an individual's clear-voiced statement.'

THE LIFE SPAN

audmatic.com

Audrey Roberts started her clothing company in Los Angeles in 2004. She often incorporates different fabrics and materials into her quirky designs. 'I like the three-dimensional element they give,' she says before explaining that it often results in complete strangers feeling compelled to try and cop a feel. 'That can be a disgusting downside,' she admits frankly.

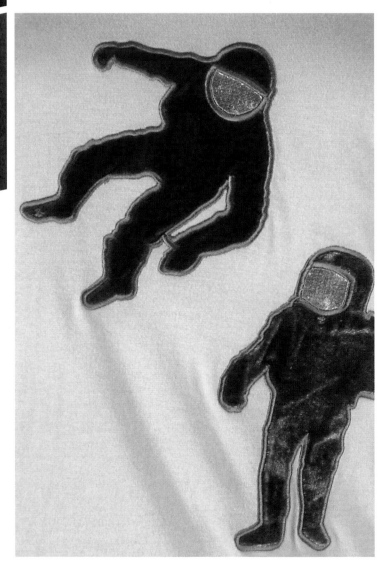

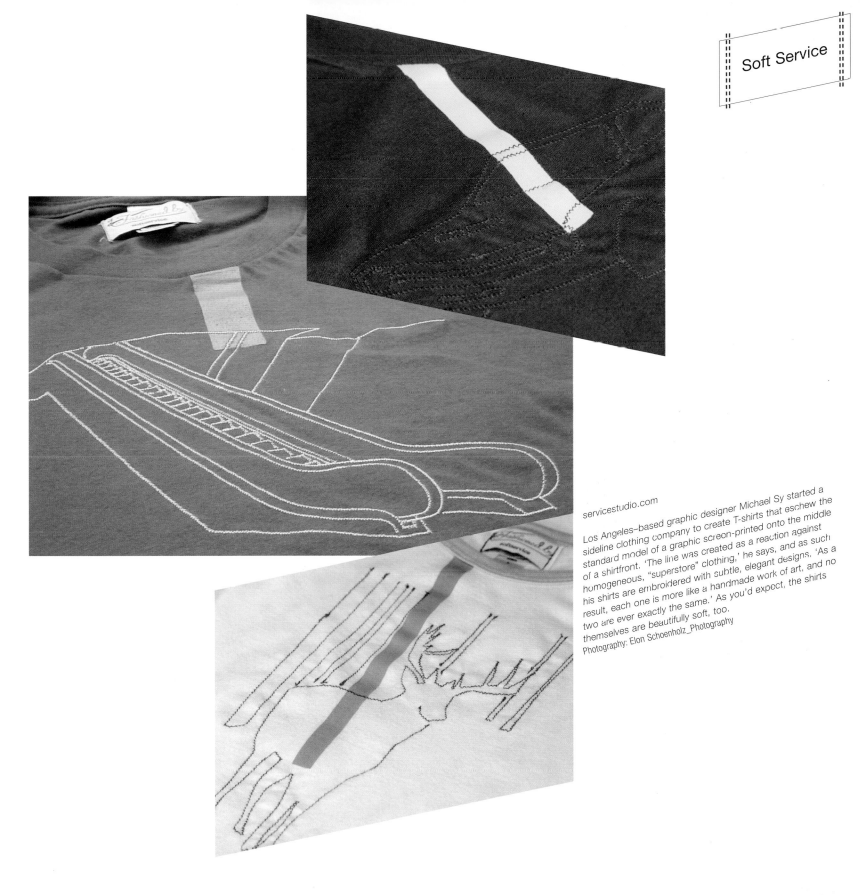

servicestudio.com

Los Angeles–based graphic designer Michael Sy started a sideline clothing company to create T-shirts that eschew the standard model of a graphic screen-printed onto the middle of a shirtfront. 'The line was created as a reaction against homogeneous, "superstore" clothing,' he says, and as such his shirts are embroidered with subtle, elegant designs, 'As a result, each one is more like a handmade work of art, and no two are ever exactly the same.' As you'd expect, the shirts themselves are beautifully soft, too.
Photography: Elon Schoenholz_Photography

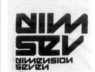
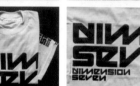

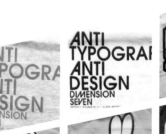

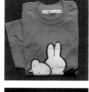

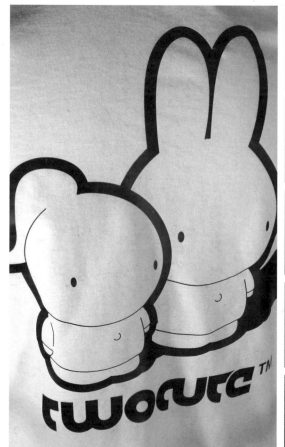

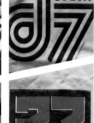

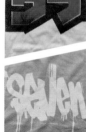

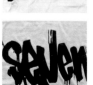
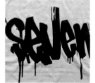

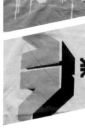
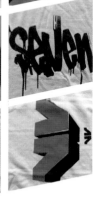

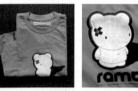

dimension7.ch

Graphic design firm Dimension 7 is based in Berlin and creates bold, eye-catching designs for their range of T-shirts that is sold via their website. Asked to describe their aesthetic, they reply: 'Up up up and down, turn turn turnaround, round round roundabout and over again.' So that's that then.

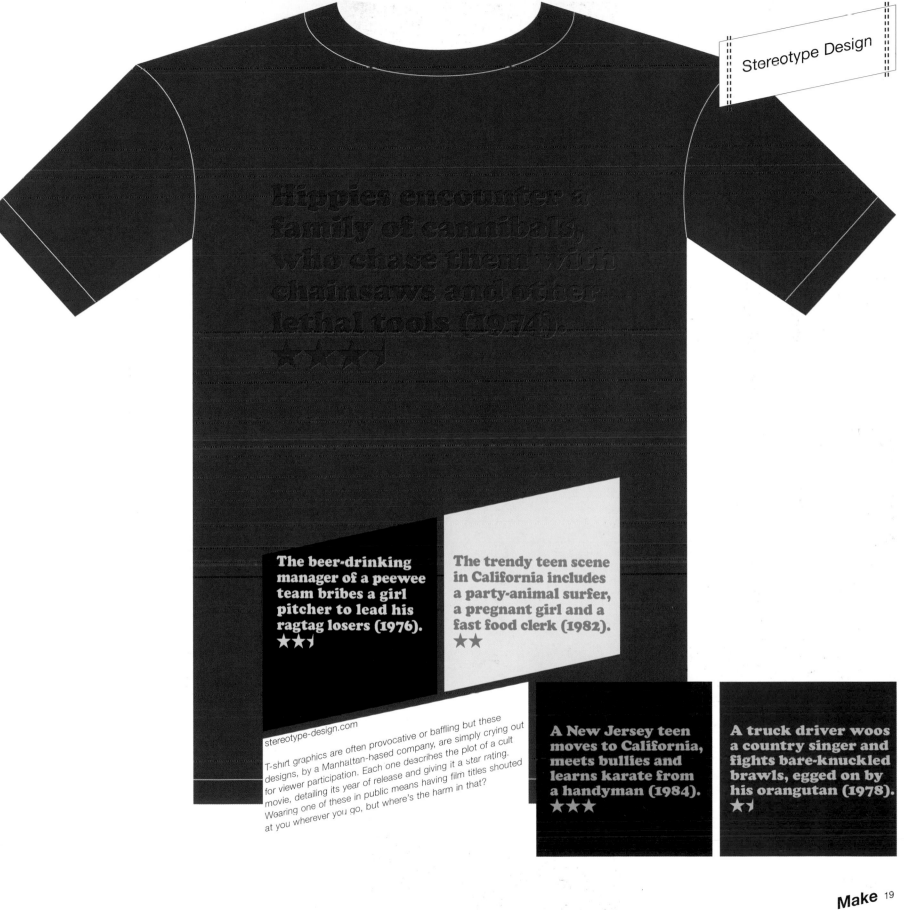

Hippies encounter a family of cannibals, who chase them with chainsaws and other lethal tools (1974). ★★★↲

The beer-drinking manager of a peewee team bribes a girl pitcher to lead his ragtag losers (1976). ★★↲

The trendy teen scene in California includes a party-animal surfer, a pregnant girl and a fast food clerk (1982). ★★

stereotype-design.com

T-shirt graphics are often provocative or baffling but these designs, by a Manhattan-based company, are simply crying out for viewer participation. Each one describes the plot of a cult movie, detailing its year of release and giving it a star rating. Wearing one of these in public means having film titles shouted at you wherever you go, but where's the harm in that?

A New Jersey teen moves to California, meets bullies and learns karate from a handyman (1984). ★★★

A truck driver woos a country singer and fights bare-knuckled brawls, egged on by his orangutan (1978). ★↲

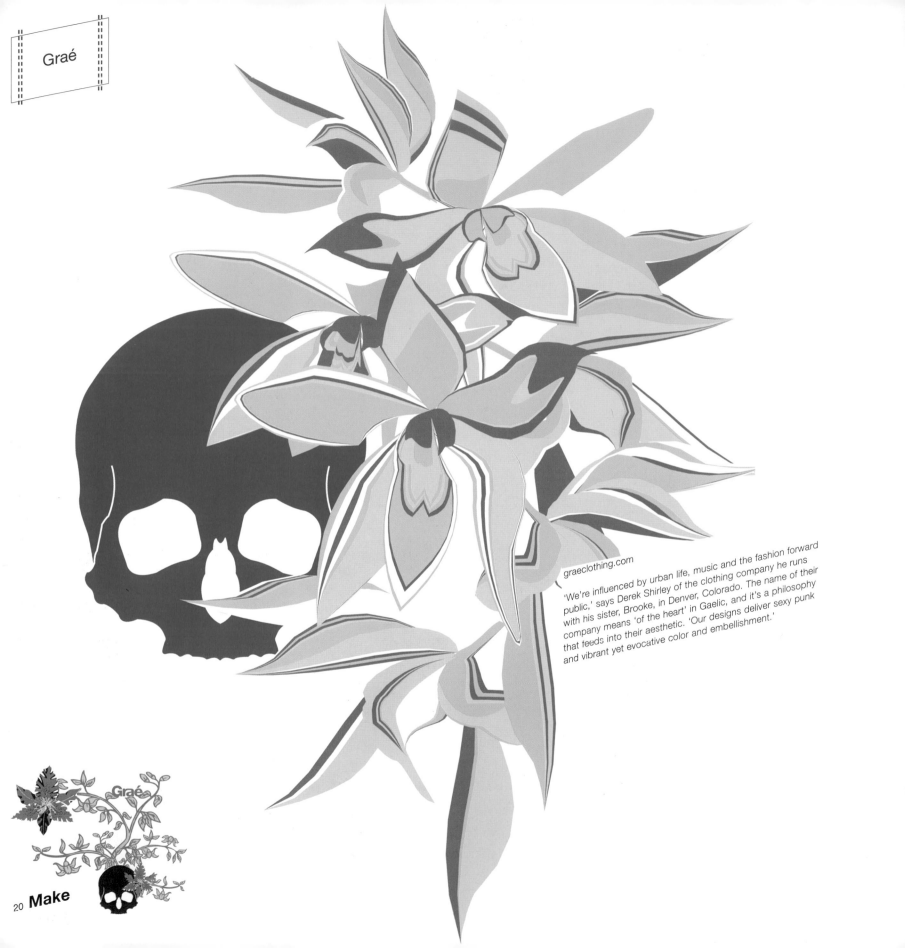

graeclothing.com

'We're influenced by urban life, music and the fashion forward public,' says Derek Shirley of the clothing company he runs with his sister, Brooke, in Denver, Colorado. The name of their company means 'of the heart' in Gaelic, and it's a philosophy that feeds into their aesthetic. 'Our designs deliver sexy punk and vibrant yet evocative color and embellishment.'

Graé

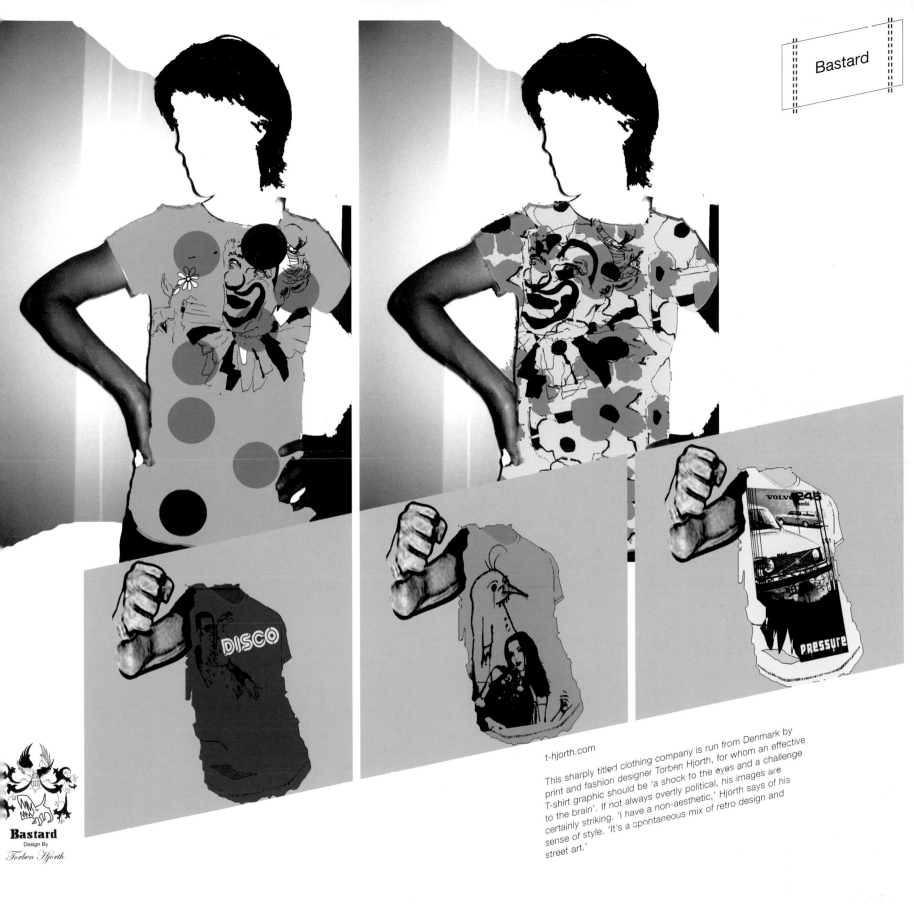

Bastard
Design By
Torben Hjorth

t-hjorth.com

This sharply titled clothing company is run from Denmark by print and fashion designer Torben Hjorth, for whom an effective T-shirt graphic should be 'a shock to the eyes and a challenge to the brain'. If not always overtly political, his images are certainly striking. 'I have a non-aesthetic,' Hjorth says of his sense of style. 'It's a spontaneous mix of retro design and street art.'

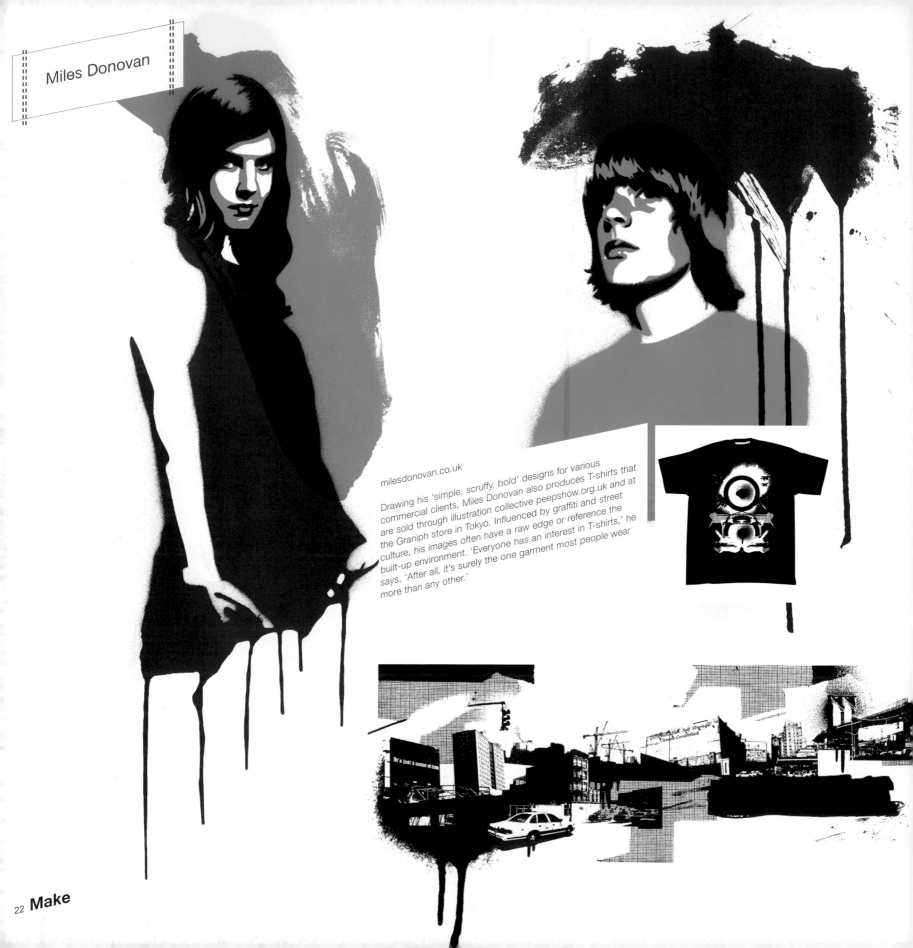

Miles Donovan

milesdonovan.co.uk

Drawing his 'simple, scruffy, bold' designs for various commercial clients, Miles Donovan also produces T-shirts that are sold through illustration collective peepshow.org.uk and at the Graniph store in Tokyo. Influenced by graffiti and street culture, his images often have a raw edge or reference the built-up environment. 'Everyone has an interest in T-shirts,' he says, 'After all, it's surely the one garment most people wear more than any other.'

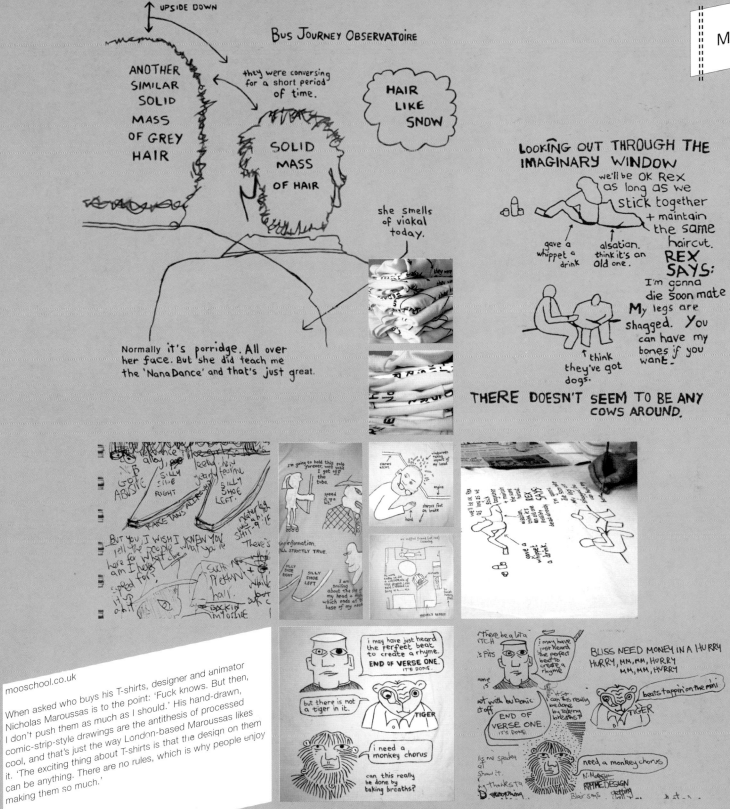

mooschool.co.uk

When asked who buys his T-shirts, designer and animator Nicholas Maroussas is to the point: 'Fuck knows. But then, I don't push them as much as I should.' His hand-drawn, comic-strip-style drawings are the antithesis of processed cool, and that's just the way London-based Maroussas likes it. 'The exciting thing about T-shirts is that the design on them can be anything. There are no rules, which is why people enjoy making them so much.'

Imaginary Foundation
·Brewing the Ridiculous since 1973·

keep it surreal

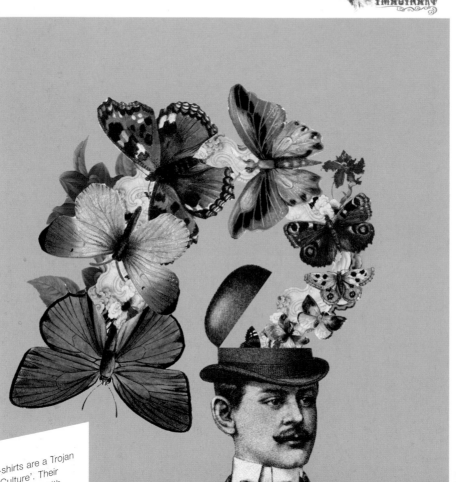

Happiness is a new idea

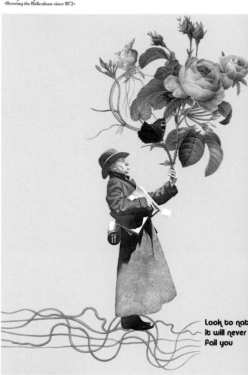

Look to nature
it will never
fail you

imaginaryfoundation.com

According to The Imaginary Foundation, 'T-shirts are a Trojan horse for injecting consciousness into Pop Culture'. Their designs often blend elaborate, old-fashioned imagery with quotes from radical thinkers, such as the claim by French Revolution leader, Antoine Saint-Just, that 'happiness is a new idea'. The results are multilayered designs that are beautiful and thought-provoking.

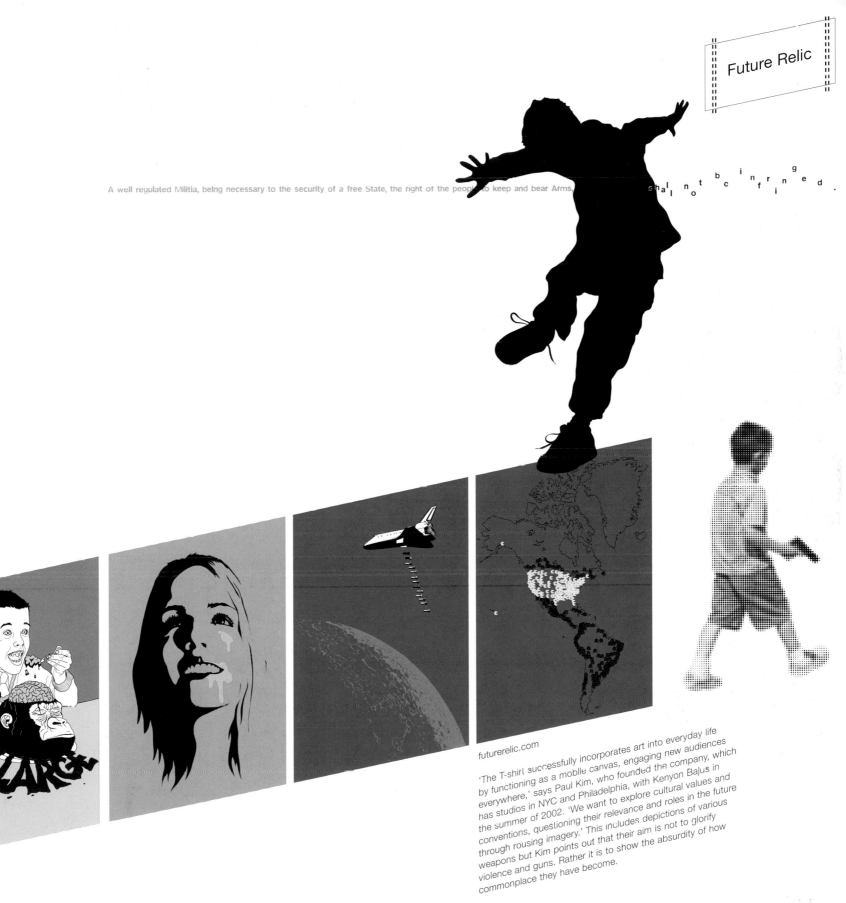

A well regulated Militia, being necessary to the security of a free State, the right of the people to keep and bear Arms, shall not be infringed.

futurerelic.com

'The T-shirt successfully incorporates art into everyday life by functioning as a mobile canvas, engaging new audiences everywhere,' says Paul Kim, who founded the company, which has studios in NYC and Philadelphia, with Kenyon Bajus in the summer of 2002. 'We want to explore cultural values and conventions, questioning their relevance and roles in the future through rousing imagery.' This includes depictions of various weapons but Kim points out that their aim is not to glorify violence and guns. Rather it is to show the absurdity of how commonplace they have become.

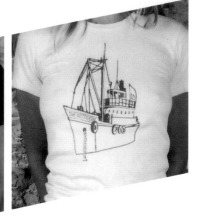

kadorable.com

It is impossible to tell the story of how Matthew Sandager and Paul Marlow started their Brooklyn-based T-shirt company any better than they do themselves. 'Once upon a time, there were jeans and sneakers that climbed trees and listened to records. They went on bike rides and took photos and dreamed of great things like buying more records and taking longer bike rides. Sometimes they were a little cold and needed to cover their skinny chests. So they went out and played with Sharpies and pencils and ink and screens and made drawings and doodles and put them on some soft cotton T-shirts.' Then they started selling them. The End. Marvellous.

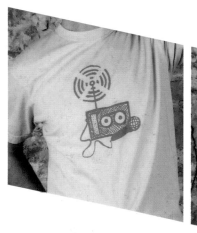

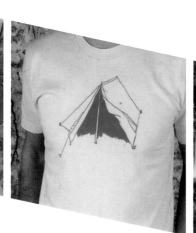

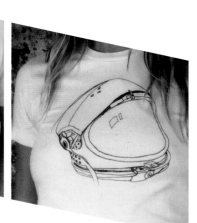

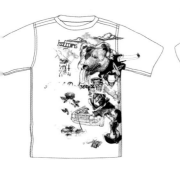
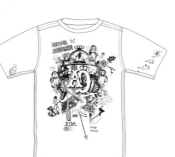
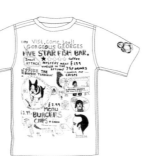

vault49.com

'There's no greater validation of one's work than when an individual parts with their personal money to own one of your designs,' says Jonathan Kenyon of New York–based company Vault49. Describing their style as 'a mishmash', they create shirts for their own collection, Roule, and for such companies as Cancer Research UK, E4, Scott Langton and Artful Dodger.

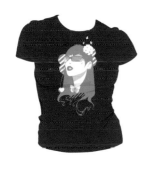

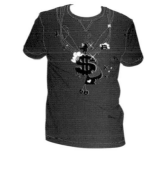

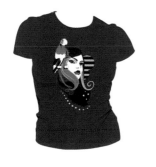
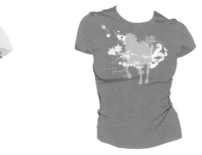
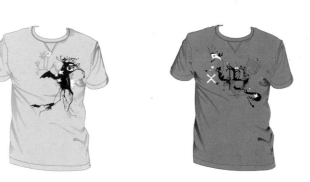

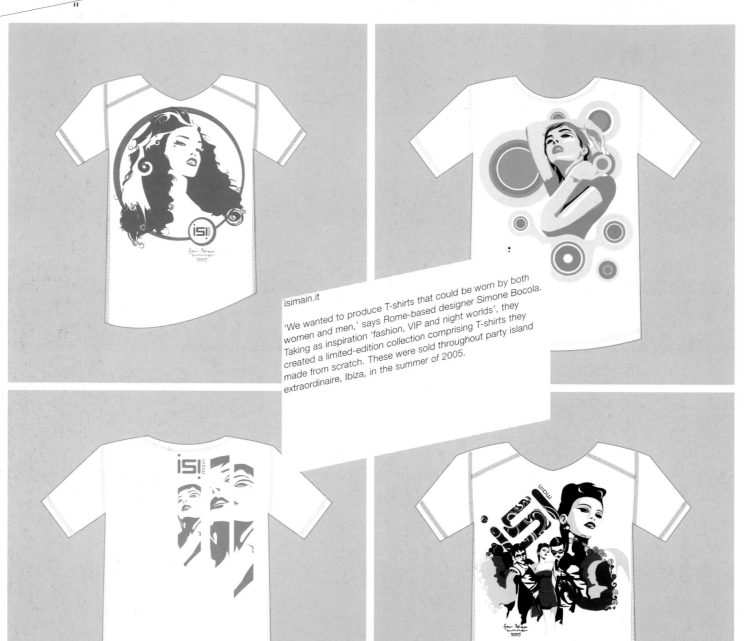

isimain.it

'We wanted to produce T-shirts that could be worn by both women and men,' says Rome-based designer Simone Bocola. Taking as inspiration 'fashion, VIP and night worlds', they created a limited-edition collection comprising T-shirts they made from scratch. These were sold throughout party island extraordinaire, Ibiza, in the summer of 2005.

pinkspike.net

Michelle Brown and Chad Jenkins are both dedicated 'vegans and animal lovers', as well as fashion and graphic designers. They opened for business on 12 September 2001, producing limited-edition T-shirts that incorporate their passion for nature, while their aesthetic displays a well-developed sense of nostalgia and whimsy.

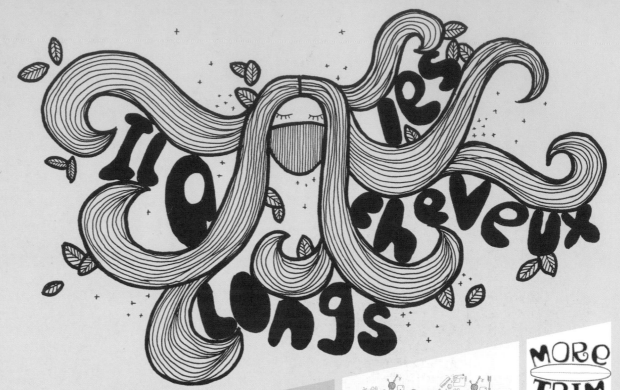

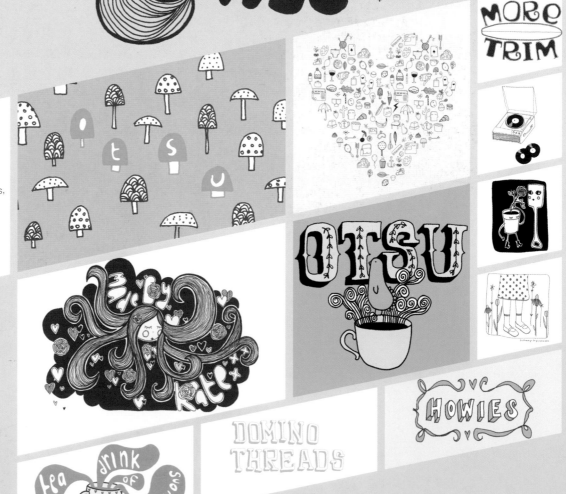

sleepycow.com

'My designs usually come straight from my sketchbook,' says illustrator Kate Sutton, founder of Sleepy Cow. 'I use a lot of hand-drawn fonts, birds and the color brown in my work too much.' She finds inspiration in things from old children's books to car boot sales to trees. To date, she has made self-promotional designs as well as work for such clients as howies, Otsu and Domino Threads.

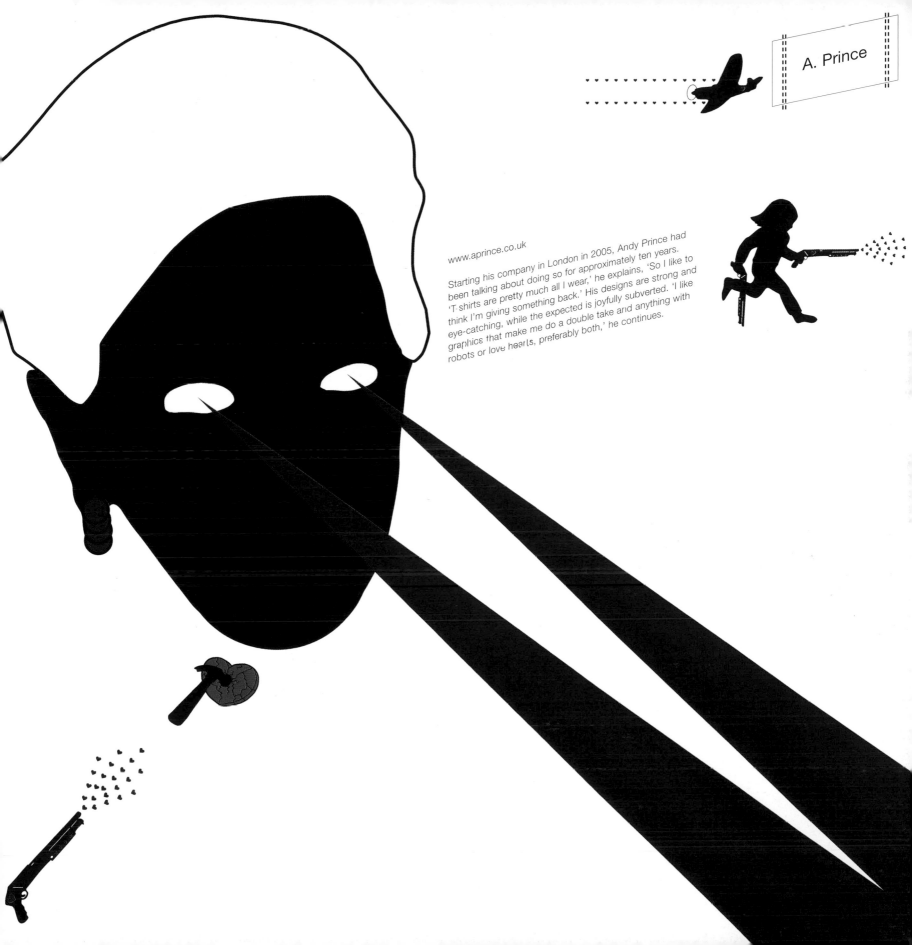

www.aprince.co.uk

Starting his company in London in 2005, Andy Prince had been talking about doing so for approximately ten years. 'So I like to 'T-shirts are pretty much all I wear,' he explains, 'So I like to think I'm giving something back.' His designs are strong and eye-catching, while the expected is joyfully subverted. 'I like graphics that make me do a double take and anything with robots or love hearts, preferably both,' he continues.

Unique

Come Camp With Me

Play

"apple"

a, e, i, o, u,
and
sometimes

why?

weareCampfire.com

The three happy campers behind this company in Akron, Ohio, are graphic designers Andy Taray and Nick Caruso and artist/printmaker Micah Kraus. Their main goal is to make good quality T-shirts that demonstrate their shared sense of humour, passion for art and love of typography. 'A good T-shirt has to incorporate an element that is eye-catching or stimulating, otherwise it will be overlooked,' says Caruso. 'We want to make shirts that are fun and energetic—and raise a smile.'

Mid?
Yes
West?
No

i before e
except
after c

weird?

11

55378008

City
of
Rubber
Akron:Ohio

I ♥ YOU

Z

**Thank You
COMMAND Z**

⌘

Camp

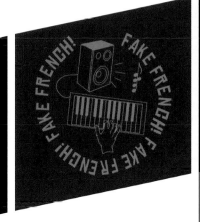

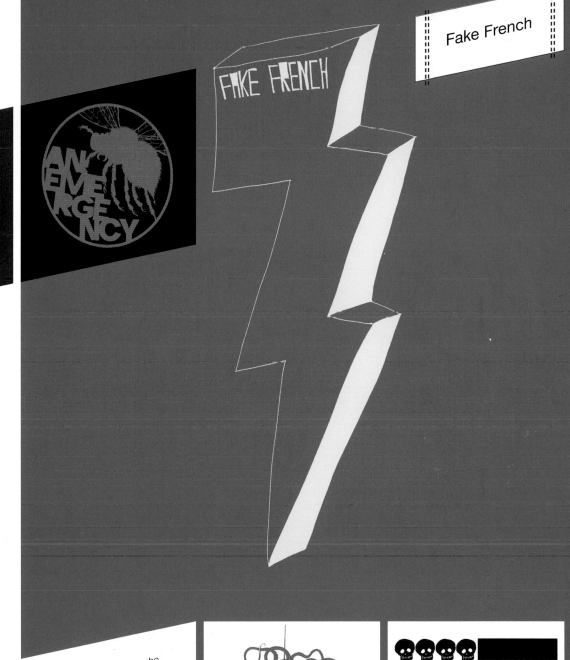

fakefrench.com

'T-shirts say a lot about people,' says Dan Reeves, who founded Fake French, based in Exeter, UK, with Tom Harman in 2004. 'We create designs for people who "get" where we're coming from aesthetically.' That's to say, bold, hand-crafted illustrations that cater to an audience of 'punk rock kids, fashionistas and cheapskates'. Many of the duo's designs are created for their personal musical endeavours – for An Emergency (Reeves's band) and Skiptracer (Harman's band).

goodatmagic.com

Richard Reynolds is a self-confessed compulsive evangelist: 'I want to spread messages about all sorts of things I feel are not fully appreciated.' This includes the joy of riding bicycles and the violent drama of pulp novels. To provide even greater detail, Reynolds also prints paragraphs of text on the inside of his shirts. His happy cyclist pictogram was created in collaboration with Turner Prize winner, Jeremy Deller.

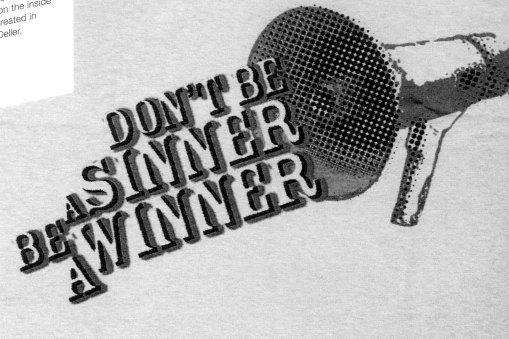

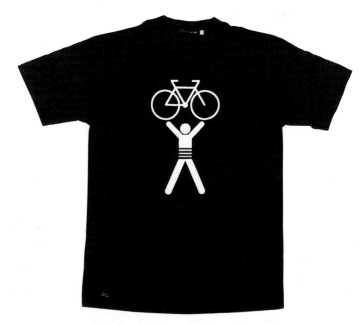

Aki Paphides collaborates with various illustrators and designers to create T-shirt graphics for a range of clients as well as for his own Swamplands label. 'I like the fact that you can put across a variety of messages on T-shirts yet still remain anonymous,' he says. Based in Bromley, Kent, UK, Paphides has been monitoring the evolution of T-shirt design for some time. 'I think the general public is becoming more aware of the statements a T-shirt can make, and subsequently expect something with a little more thought in it than just a cheap "knob" gag,' he says, adding, 'Though I'm sure that has its place somewhere.'

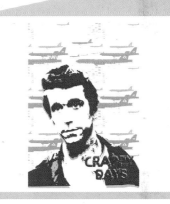

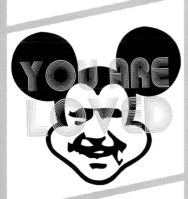

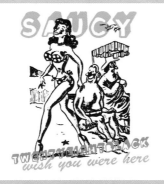

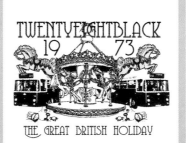

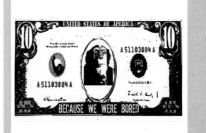

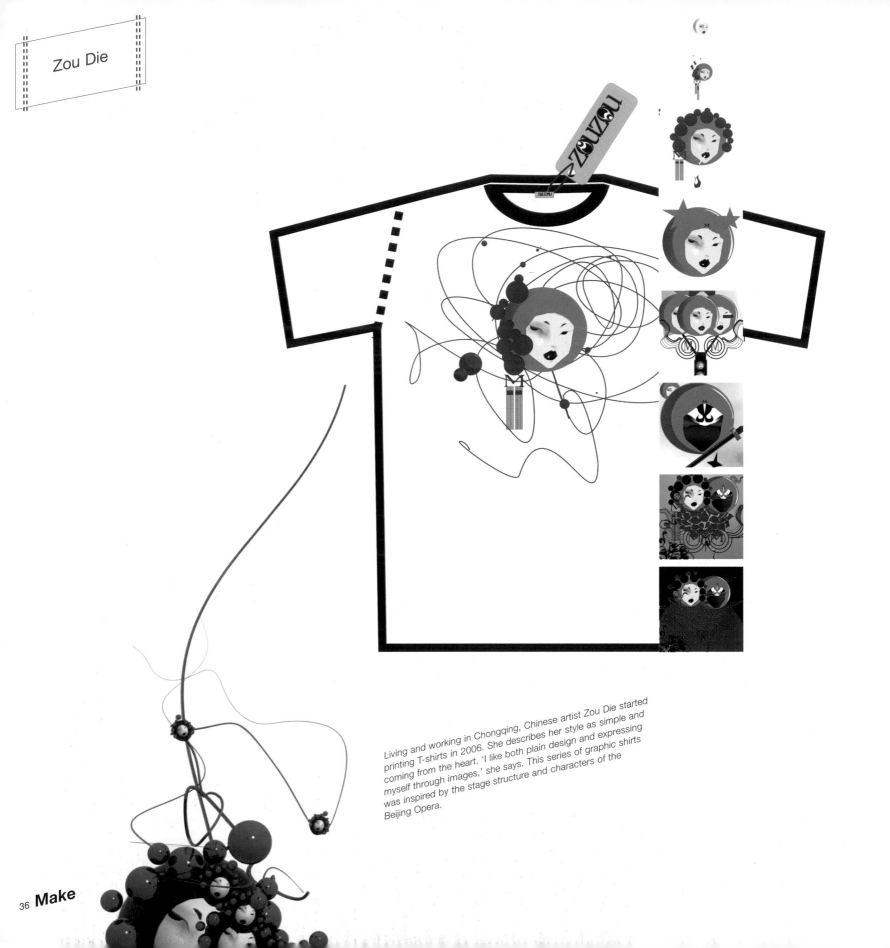

Zou Die

Living and working in Chongqing, Chinese artist Zou Die started printing T-shirts in 2006. She describes her style as simple and coming from the heart. 'I like both plain design and expressing myself through images,' she says. This series of graphic shirts was inspired by the stage structure and characters of the Beijing Opera.

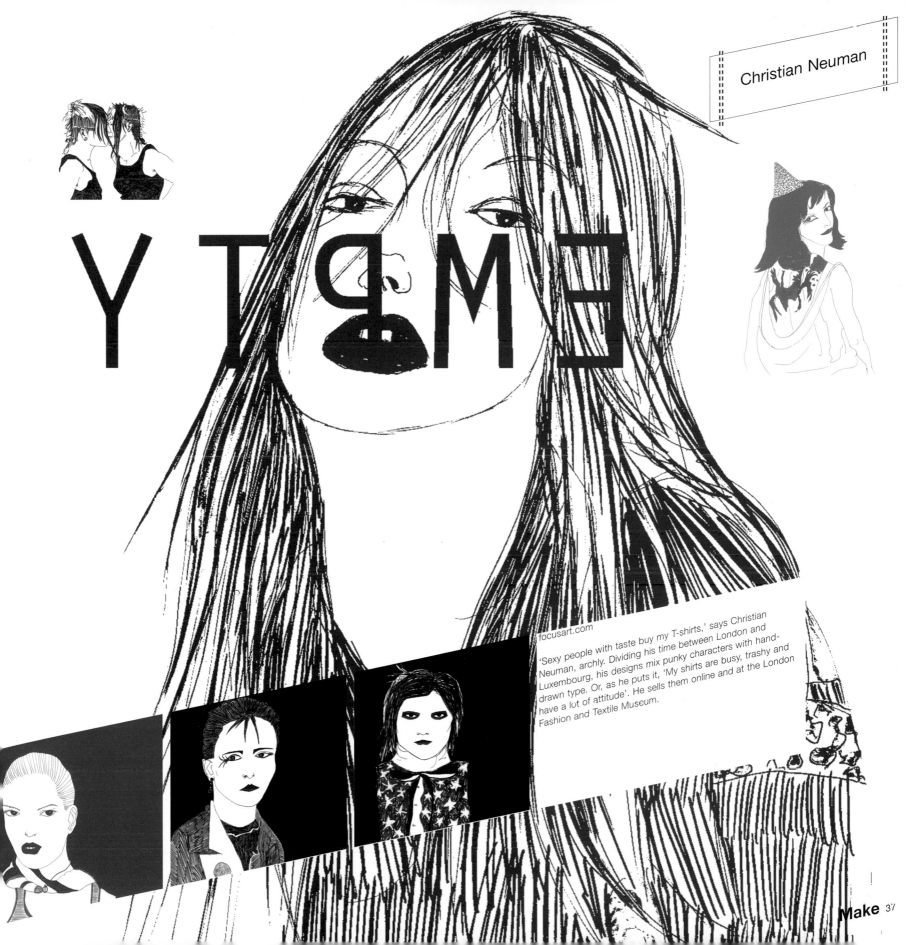

EMPTY

focusart.com

'Sexy people with taste buy my T-shirts,' says Christian Neuman, archly. Dividing his time between London and Luxembourg, his designs mix punky characters with hand-drawn type. Or, as he puts it, 'My shirts are busy, trashy and have a lot of attitude'. He sells them online and at the London Fashion and Textile Museum.

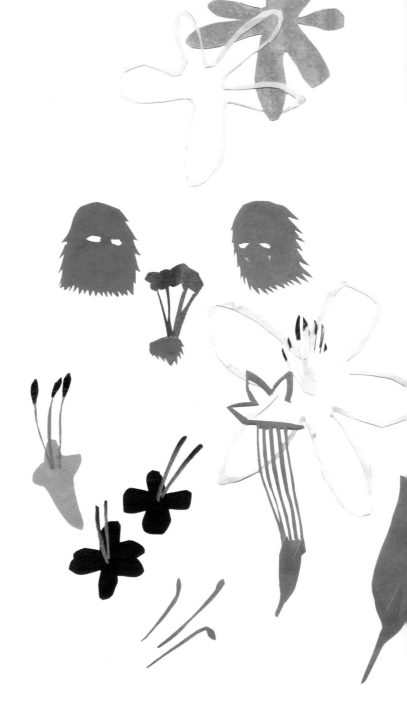

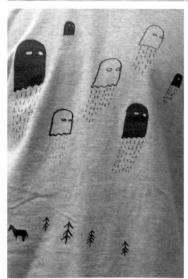

lukebest.com

London-based illustrator, animator and designer Luke Best explains, 'The T-shirt is a disposable item but also a much-loved and treasured object'. Rather self-deprecatingly, he describes his style as 'a work in progress'. His simple drawings are imbued with wit and grace.

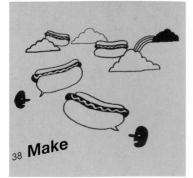

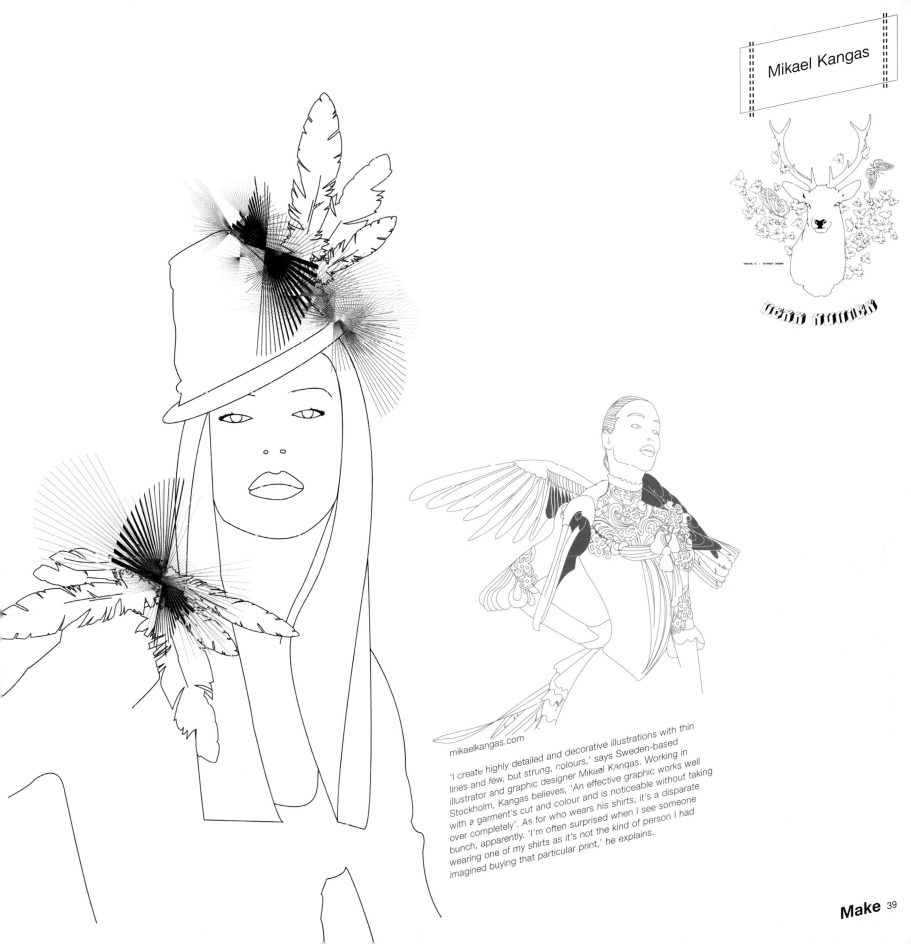

mikaelkangas.com

'I create highly detailed and decorative illustrations with thin lines and few, but strong, colours,' says Sweden-based illustrator and graphic designer Mikael Kangas. Working in Stockholm, Kangas believes, 'An effective graphic works well with a garment's cut and colour and is noticeable without taking over completely'. As for who wears his shirts, it's a disparate bunch, apparently. 'I'm often surprised when I see someone wearing one of my shirts as it's not the kind of person I had imagined buying that particular print,' he explains.

ilovedust.com

Cute icons abound on shirts from this UK-based design company, probably best known for the Designed to Help book project they curated to raise money for those affected by the Asian tsunami. Working out of Southsea, their style is wilfully, deliberately eclectic. Or, as creative director Mark Graham puts it, 'Some of the graphics are simple, some of them aren't'.

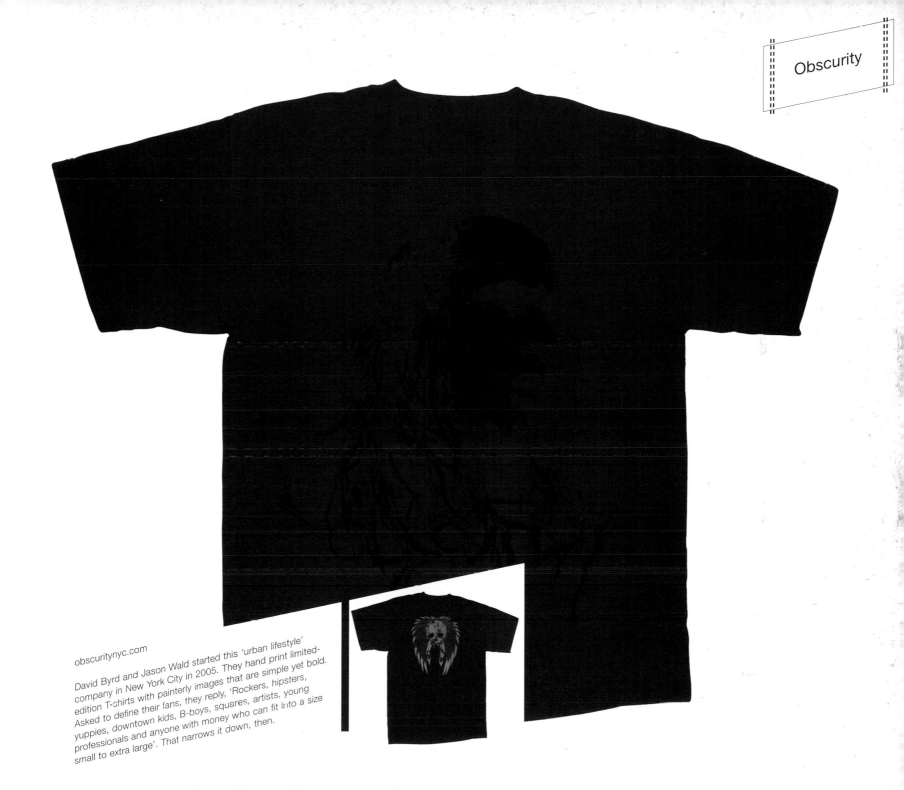

obscuritynyc.com

David Byrd and Jason Wald started this 'urban lifestyle' company in New York City in 2005. They hand print limited-edition T-shirts with painterly images that are simple yet bold. Asked to define their fans, they reply, 'Rockers, hipsters, yuppies, downtown kids, B-boys, squares, artists, young professionals and anyone with money who can fit into a size small to extra large'. That narrows it down, then.

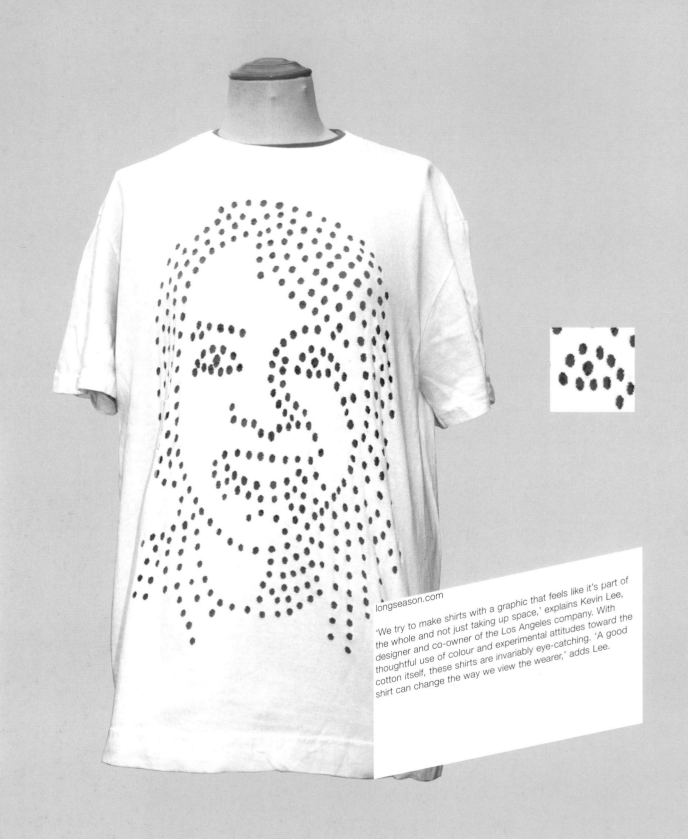

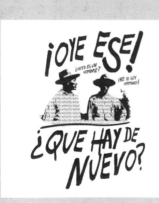

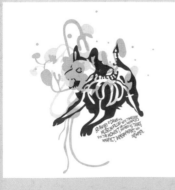

longseason.com

'We try to make shirts with a graphic that feels like it's part of the whole and not just taking up space,' explains Kevin Lee, designer and co-owner of the Los Angeles company. With thoughtful use of colour and experimental attitudes toward the cotton itself, these shirts are invariably eye-catching. 'A good shirt can change the way we view the wearer,' adds Lee.

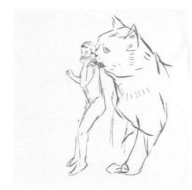

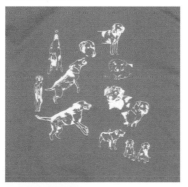

victorschechter.com

Kaiko'o Victor and Asha Schechter run their company between New York and San Francisco. They commission artists they admire, such as Ken Kagazmi, Satomi Matsuzaki, Will Rogan, Leanne Shapton and Trevor Shimizu, to create shirt graphics, as well as designing shirts themselves. 'We try to put out shirts that are not ironic, gimmicky or obnoxious,' says Victor. 'Our designs are meant to be subtle and delicate through the use of color and line.'

squidfire.com

'Most silk screeners try to brand themselves too quickly, or use vulgar language and symbols as a way to attract customers. We'd rather focus on great art,' comments Jean-Baptiste Regnard, who founded Squidfire with Kevin Sherry in Baltimore, Maryland in 2004. Alongside T-shirts for regular-sized humans, they also design clothes for small ones. 'Once a very pregnant lady bought some of our baby clothes,' says Regnard. 'It was weird thinking that we were dressing a person who wasn't even born yet.'

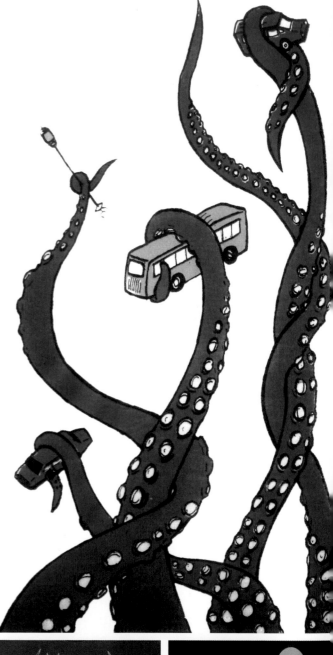

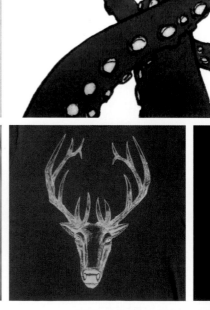

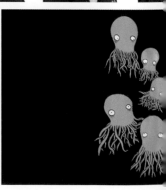

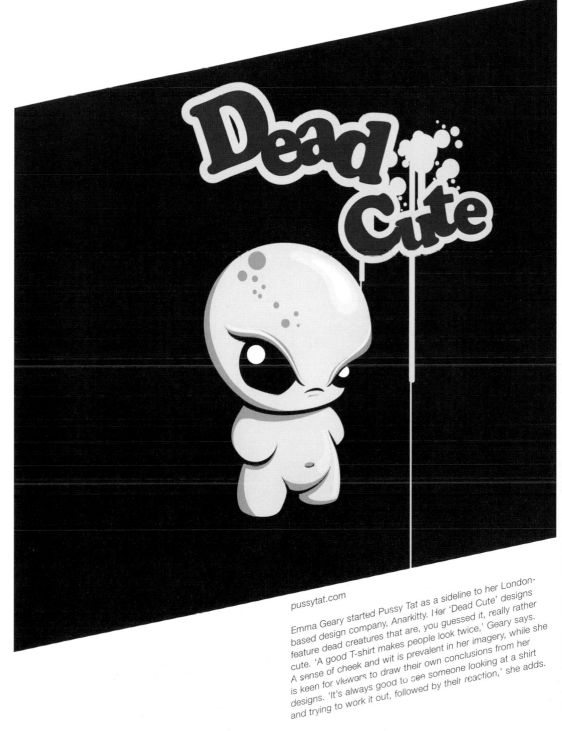

pussytat.com

Emma Geary started Pussy Tat as a sideline to her London-based design company, Anarkitty. Her 'Dead Cute' designs feature dead creatures that are, you guessed it, really rather cute. 'A good T-shirt makes people look twice,' Geary says. A sense of cheek and wit is prevalent in her imagery, while she is keen for viewers to draw their own conclusions from her designs. 'It's always good to see someone looking at a shirt and trying to work it out, followed by their reaction,' she adds.

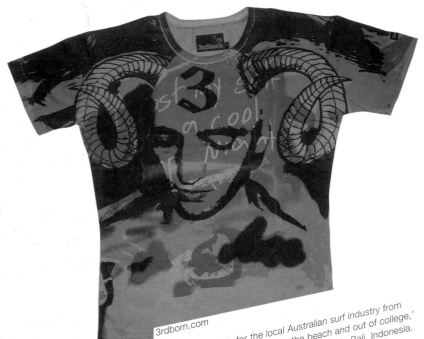

3rdborn.com

'I designed T-shirts for the local Australian surf industry from a young age. It kept me close to the beach and out of college,' says David Eagles, who now lives and works in Bali, Indonesia. By the age of 22, he was working full time as a graphic designer for Quiksilver and, in 2000, he launched his own clothing label. He prints versions of his personal art pieces onto T-shirts, explaining, 'My art usually portrays images of good and evil. Sometimes it's hard to define which is the more influential on my work.'

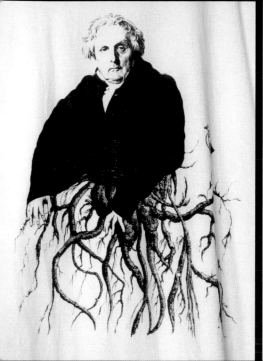

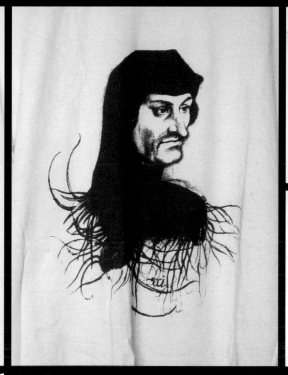

olnmayne.com

tralian designer Lincoln Mayne revels in an unconventional roach to fashion design. Trained as a sculptor in his native th, he worked as an installation artist for the BBC In London ore moving to New York in 2001, where ho taught himself ew and print and founded his eponymous fashion line. bold graphics have an old-fashioned feel but they are also kingly original. His eye for detail is demonstrated in his astically precise prints. Photography: Isak Tiner, isaktiner.com

CA

IKCA
IANKELTIE.
COM

.IKCA
I'VE GOT SOUL BUT I'M NOT A SOLDIER

FASTCARS

WE L♥VE JEANS

THEKILLERSROCK!

EAT CRAP BE COOL

WE LOVE JEANS

iankeltie.com

Based in Newcastle-upon-Tyne, UK, Ian Keltie explains, 'It all started years ago, seeing Shaggy in Scooby Doo. He was my favourite character and always wore a T-shirt and always looked cool.' Now Keltie designs his own shirts, for himself and for his label, We Love Jeans. He doesn't believe that T-shirts have to make a deep and meaningful statement. For him, it's more important that they look 'cool as hell'. He adds, 'But if you can do that and make a statement then I take my hat off to ya.'

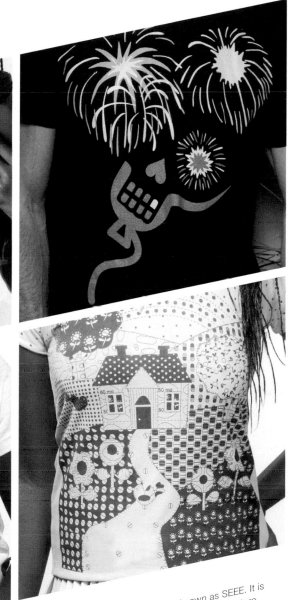

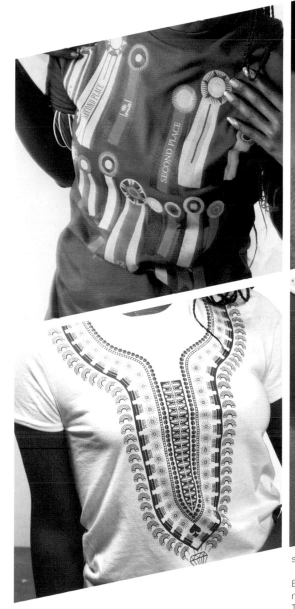

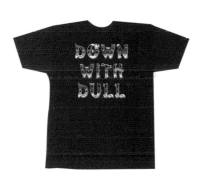

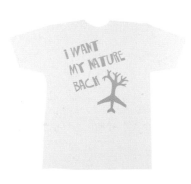

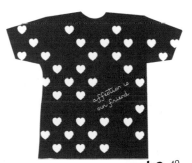

seee.us

Based in Harlem, NYC, this line is also known as SEEE. It is named after founder Jennifer Garcia's favourite thrift store T-shirt. 'It was an electrician's baseball league jersey that had "Star Electric" on the front and an 88 on the back,' she explains. Exuberant and stylish, her colourful designs use the whole shirt as a canvas. 'I saw a guy at a Björk concert who was wearing one of my designs,' Garcia adds happily. 'I ran up to him and gave him a big hug. Is that weird?'

Shoot

T-shirts: a photoessay. The T-shirt as we all know and love it, out and about, on your chest and in your face.

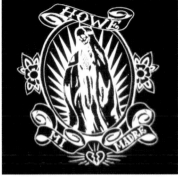

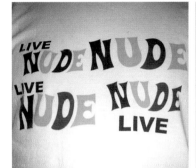

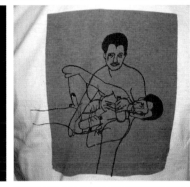

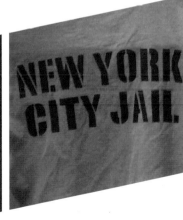

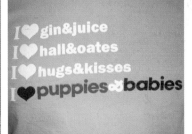

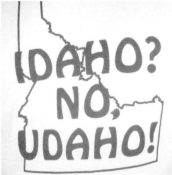

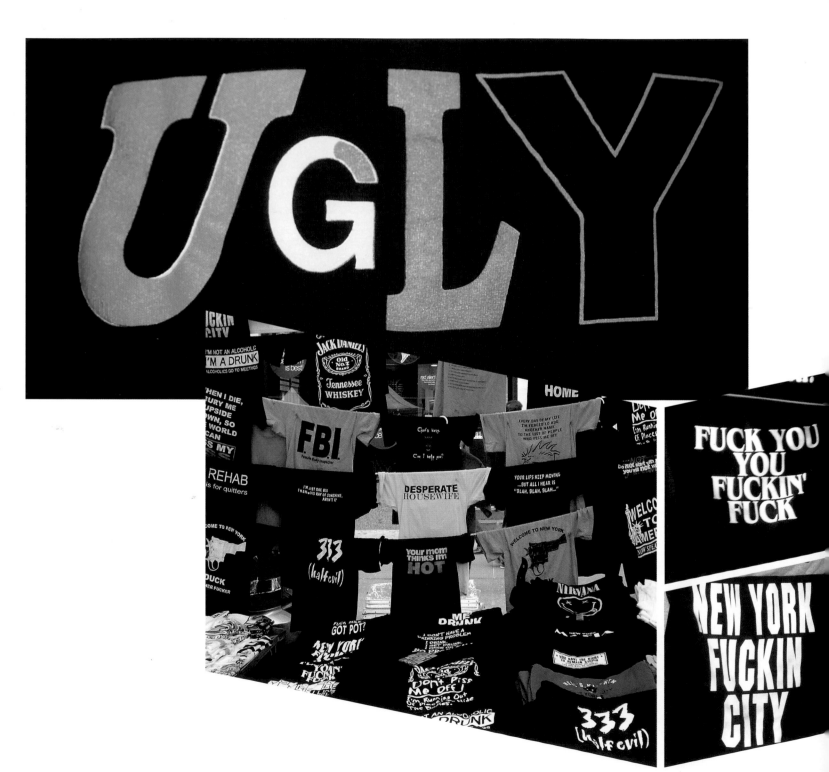

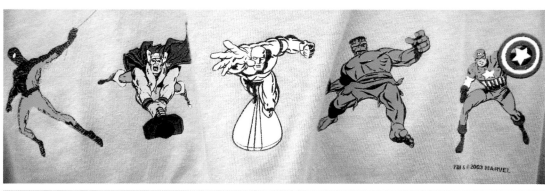

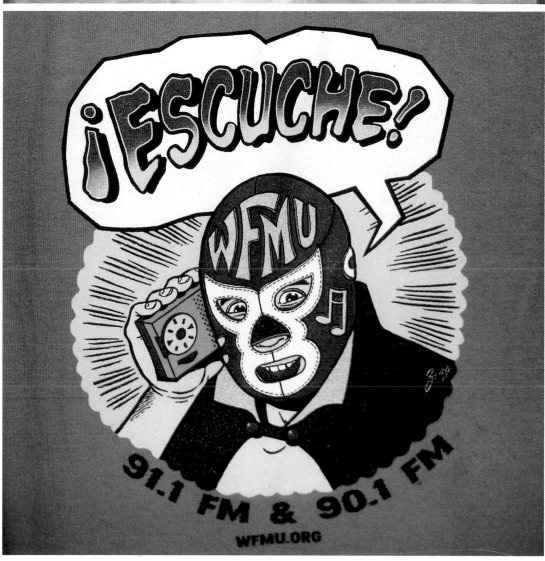

It's 'BETTER IN SYRIA

"heroine"

Green Mountains, Vermont
SEEKING TO FULFILL GOD'S PROMISE

MAKOSSA

PRATO 9

EMPLOYEES MUST WASH HAND

SECURITY

I'M RICK JAMES. BITCH!

I HAVE OCPD

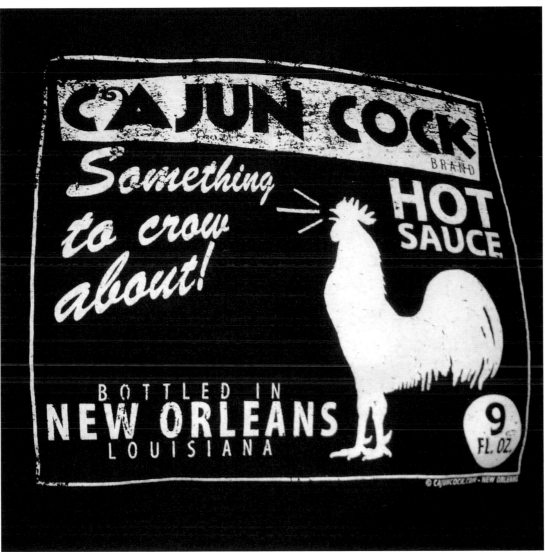

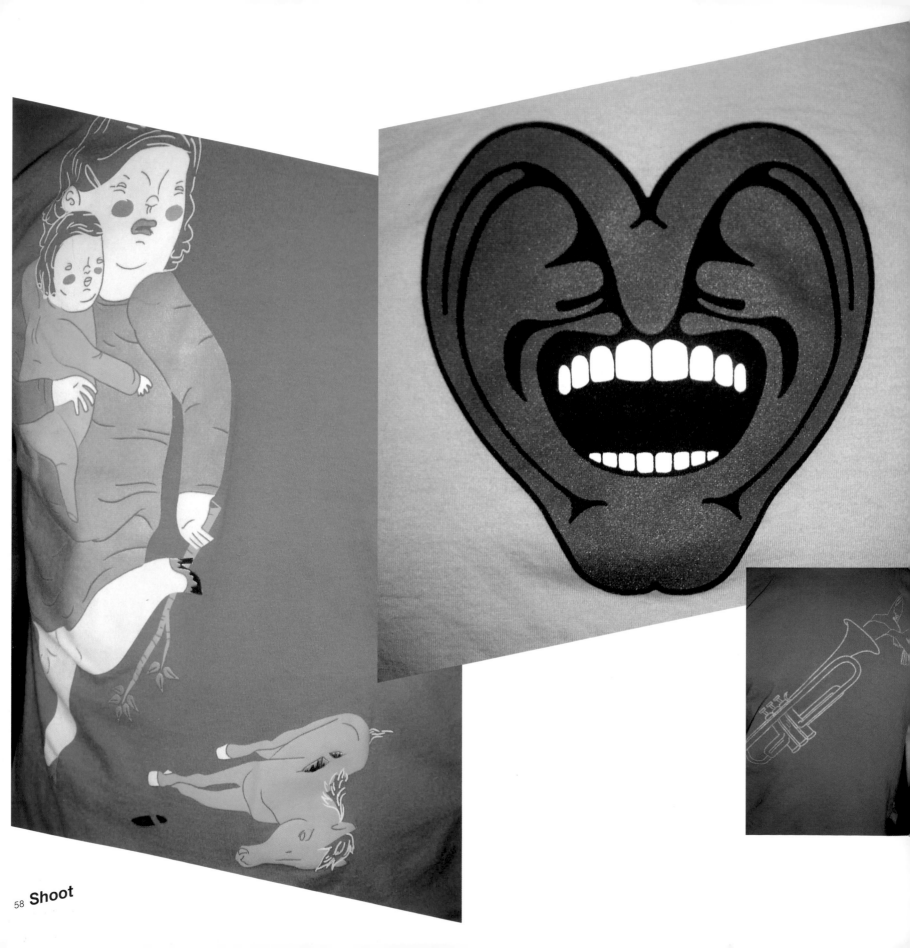

narcissist

nar·cis·sist \n\:
Excessive love or admiration of oneself characterized by self-preoccupation and lack of empathy.

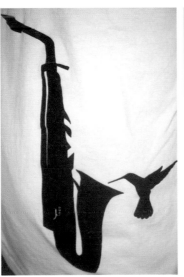

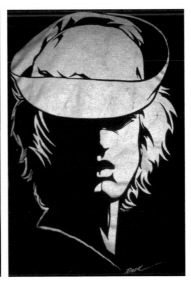
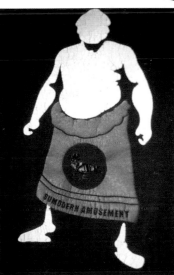

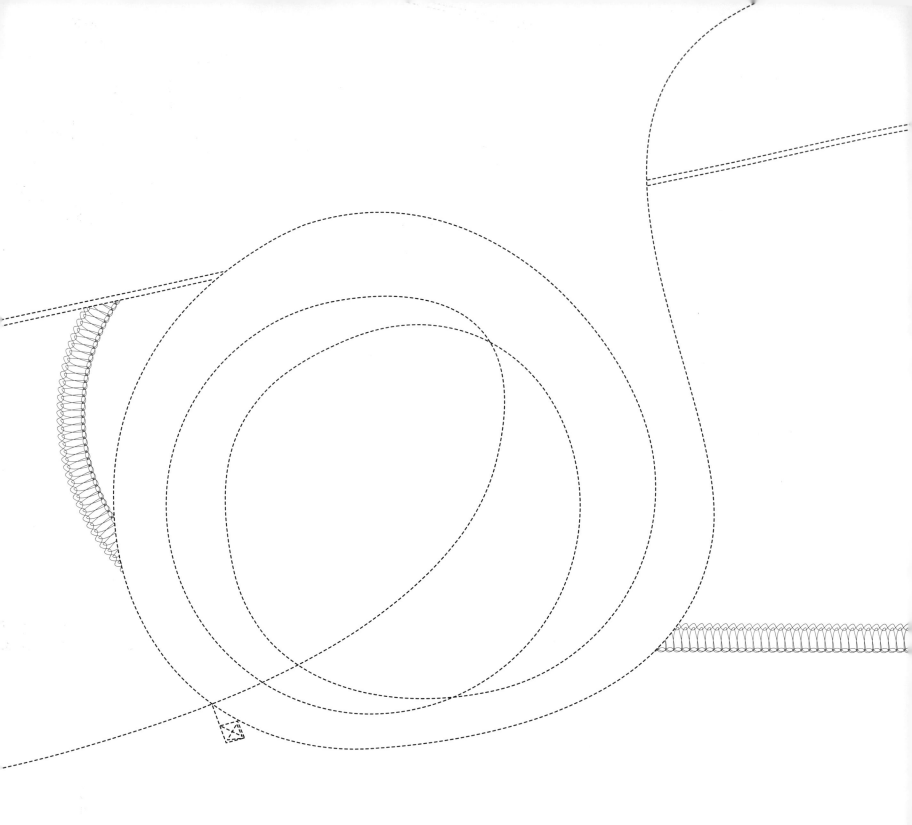

300%

300%

300% is a ridiculous concept, scoffed at by all who hear it. But we didn't let that deter us, oh no. We went ahead and invited an array of well-respected designers from around the world to do their worst and come up with an image based on this theme. And, bless 'em all, they did just that.

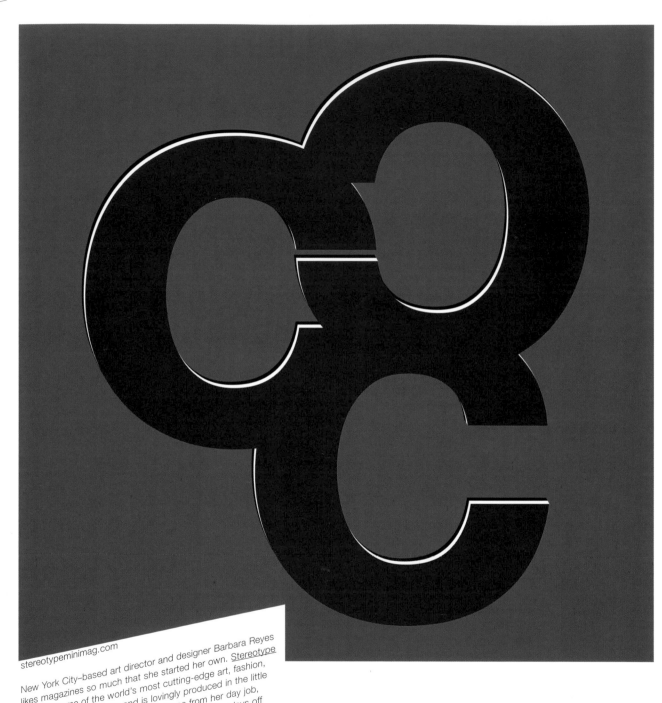

stereotypeminimag.com

New York City–based art director and designer Barbara Reyes likes magazines so much that she started her own. Stereotype features some of the world's most cutting-edge art, fashion, design and photography and is lovingly produced in the little spare time Reyes has after getting home from her day job, art directing Teen People. Her clever 300% design plays off both the idea of the number three and the percent symbol. 'A percentage refers to a part of a whole: a percentage beyond the value of one can be achieved only when making comparisons to the original,' she explains. 'The copy is not a part of the original.'

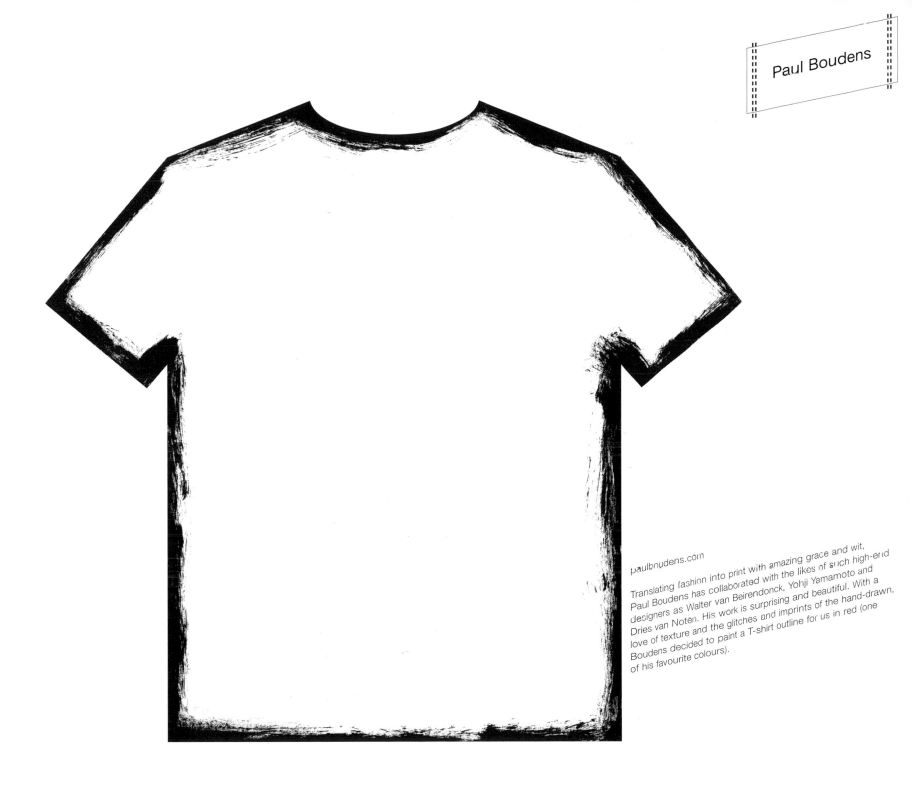

paulboudens.com

Translating fashion into print with amazing grace and wit, Paul Boudens has collaborated with the likes of such high-end designers as Walter van Beirendonck, Yohji Yamamoto and Dries van Noten. His work is surprising and beautiful. With a love of texture and the glitches and imprints of the hand-drawn, Boudens decided to paint a T-shirt outline for us in red (one of his favourite colours).

Hort

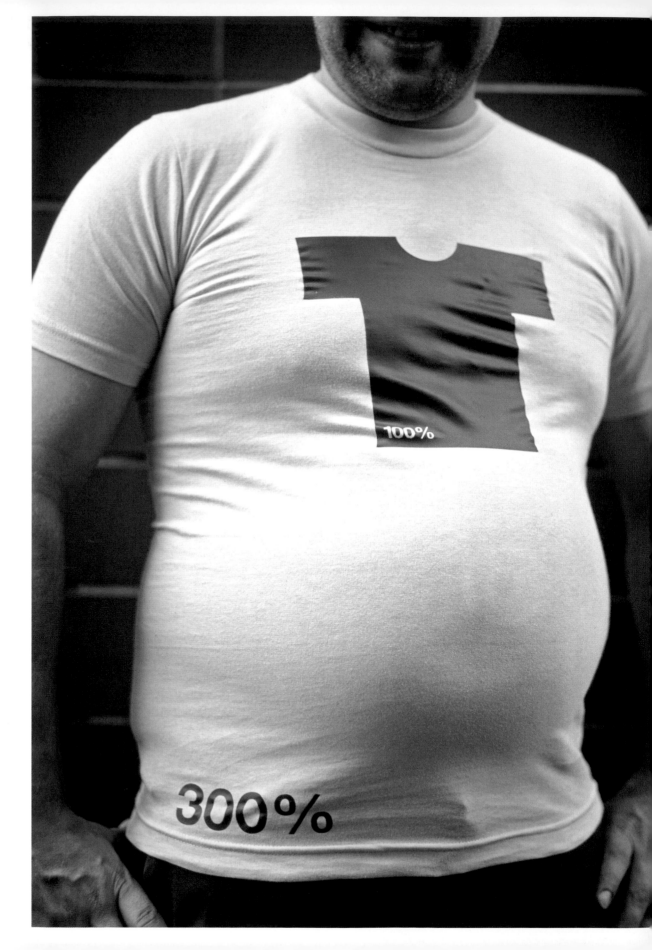

hort.org.uk

Based in Germany, the design company Hort created this witty, tongue-in-cheek 300% design to play off the idea of size and proportion. Impressively, they also persuaded someone – who swears he's not pregnant – to model the shirt for the photograph.

mike-slack.com

Mike Slack lives and works in Los Angeles. Specializing in creating Polaroid pictures, he has a keen eye for the beautifully banal and has seen his work exhibited in numerous galleries. His 300% submission is a take on the idea of triplicate and the allure of repetition. Slack's latest book of photographs, Scorpio, is published by The Ice Plant.

graff1.com

A prolific designer and typographer, John Simpson delights in creating layered images that provoke and inspire. His graphic experiments continually challenge viewers to reconsider how they look at design. He describes his 300% submission as 'a graffiti, camouflage, floating island, car engine', while he adds the statement about barcodes 'because that's my answer to design discussions about brands'. The embroidery was inspired by the back of a clothing label. 'The back's always a mess of cotton lines that's still legible in some way,' Simpson explains. 'I set about trying to emulate the feel of it.'

300 PERCENT 300PERCENTTHEBRANDEDESHTITLE

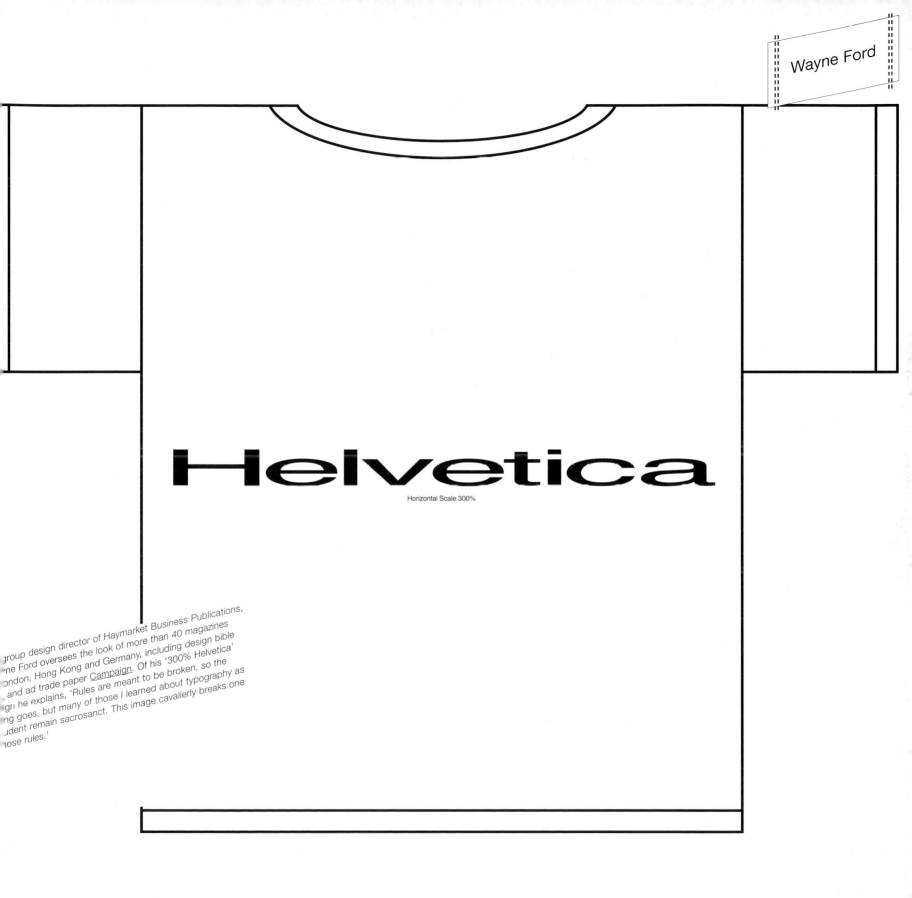

Wayne Ford

Helvetica

Horizontal Scale 300%

...group design director of Haymarket Business Publications, ...ne Ford oversees the look of more than 40 magazines ...ondon, Hong Kong and Germany, including design bible ... and ad trade paper Campaign. Of his '300% Helvetica' ...gn he explains, 'Rules are meant to be broken, so the ...ng goes, but many of those I learned about typography as ...udent remain sacrosanct. This image cavalierly breaks one ...hose rules.'

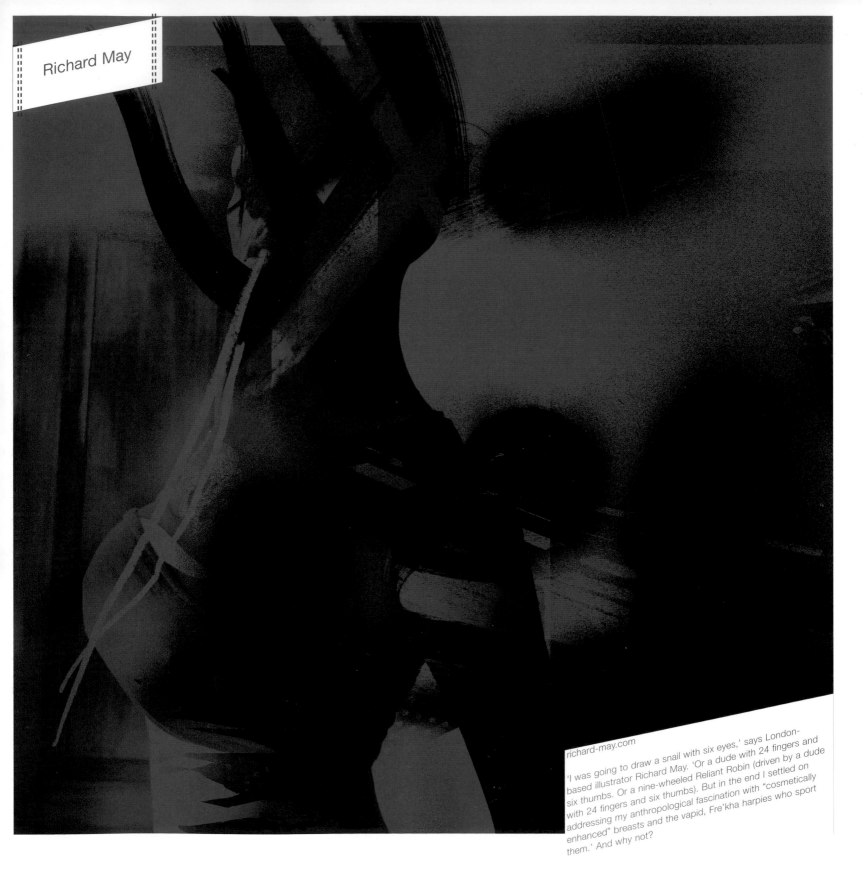

richard-may.com

'I was going to draw a snail with six eyes,' says London-based illustrator Richard May. 'Or a dude with 24 fingers and six thumbs. Or a nine-wheeled Reliant Robin (driven by a dude with 24 fingers and six thumbs). But in the end I settled on addressing my anthropological fascination with "cosmetically enhanced" breasts and the vapid, Fre'kha harpies who sport them.' And why not?

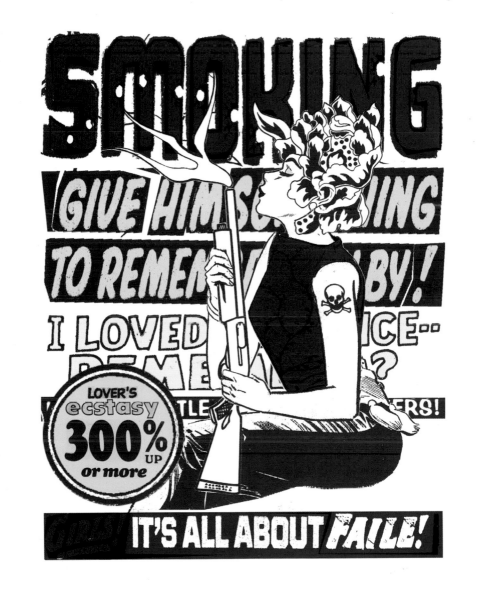

faile.net

The three members of art collective Faile hail from Japan, Canada and the US, and they are well known for the art they throw up in public spaces all over the world. Gleefully mixing a sense of urban edge with sophisticated cool, their images are striking, typographic and humorous.

ohioboy.com

'I wanted to create a shirt that took a fun and cute direction on 300%,' says Brooklyn-based designer Andy Taray. 'Plus I guess it's a dedication to the long dog fan in all of us. Here's to the wiener dog!' Taray creates his humorous but exquisitely detailed designs for a variety of clients, including MTV Networks, while he's also a typography and design instructor at the School of Visual Arts in New York.

300% longer

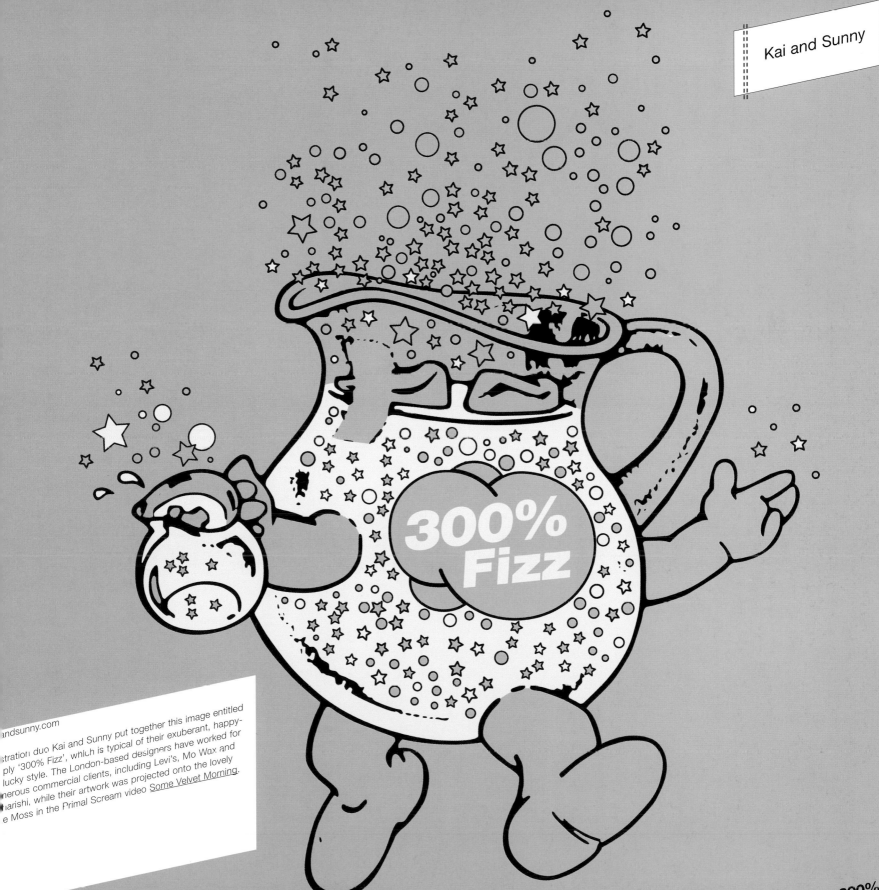

...andsunny.com

...stration duo Kai and Sunny put together this image entitled ...ply '300% Fizz', which is typical of their exuberant, happy- ...lucky style. The London-based designers have worked for ...nerous commercial clients, including Levi's, Mo Wax and ...narishi, while their artwork was projected onto the lovely ...e Moss in the Primal Scream video Some Velvet Morning.

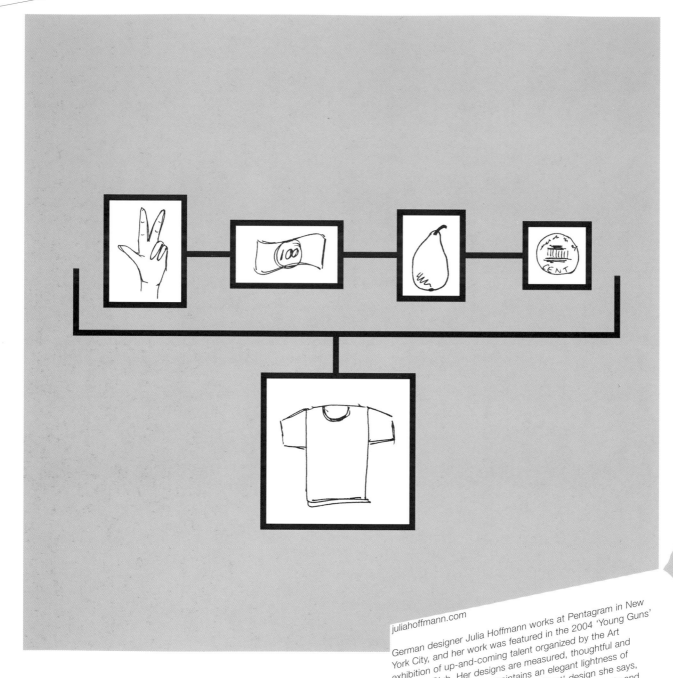

juliahoffmann.com

German designer Julia Hoffmann works at Pentagram in New York City, and her work was featured in the 2004 'Young Guns' exhibition of up-and-coming talent organized by the Art Directors Club. Her designs are measured, thoughtful and precise, while she deftly maintains an elegant lightness of touch. Of her 'Three Hundred Pe(a)r Cent' design she says, 'When I think of percentages, I think of numbers, charts and graphs. But 300% does not exist; it is an exaggeration. So I thought I would illustrate it with pictures instead of numbers, to give it a more fictional quality.'

romanticsurf.com

The work of French artist Elisabeth Arkhipoff is conceptual and exquisitely detailed. Frequently collaborating with other designers, such as fellow Parisian Laurent Fétis, she creates work for a range of clients from the world of contemporary culture, including fashion and music. Refusing to restrict herself to one medium, she works in multiple creative disciplines – painting, sculpture and installation – and recently began to experiment with film and direction. Her 300% design combines a restrained use of colour with an experimental take on perspective.

100% Bullshit
HOMOSEXUALITY IS SIN!
+ 100% Bullshit
ISLAM IS A LIE!
+ 100% Bullshit
ABORTION IS MURDER!

Some issues are just black and white!
300% Bullshit

odonnell-design.com

Timothy O'Donnell is well known for the work he did during a four-year stint with Vaughan Oliver at the v23 studio in London, creating music packaging for 4AD Records, among others. Since returning to his native US, he has worked for the likes of MTV, Razorfish and HBO. 'T-shirts are great message boards,' he says of his 300% idea. 'The problem with proudly intolerant messages like this is that they make you question the benefits of free speech. But, rather than censoring different viewpoints, I like the idea of overprinting them with your rebuttal.'

Acclaimed Irish illustrator Brian Cronin exploited the quirks of his native dialect for this beautifully spare 300% design: in his world, 'tree' is 'three'. He creates his images for such magazines as The New York Times, Esquire and Rolling Stone, and his eye for detail and painterly vision have resulted in a stunning body of work that is masterfully restrained and meticulously detailed.

lloydblander.com

Canadian graphic designer Lloyd Blander works in the Manhattan office of branding giant Siegel & Gale, producing simple but powerful designs for the likes of American Express, Allstate and The New School, for which he developed an entirely new identity in 2005. He also produces short films and collaborates on art installations. His 300% design takes on a familiar urban sight: the pigeon. 'Pigeons are everywhere in New York,' he explains. 'I feel like 300% is also everywhere… you just have to keep your eyes open.'

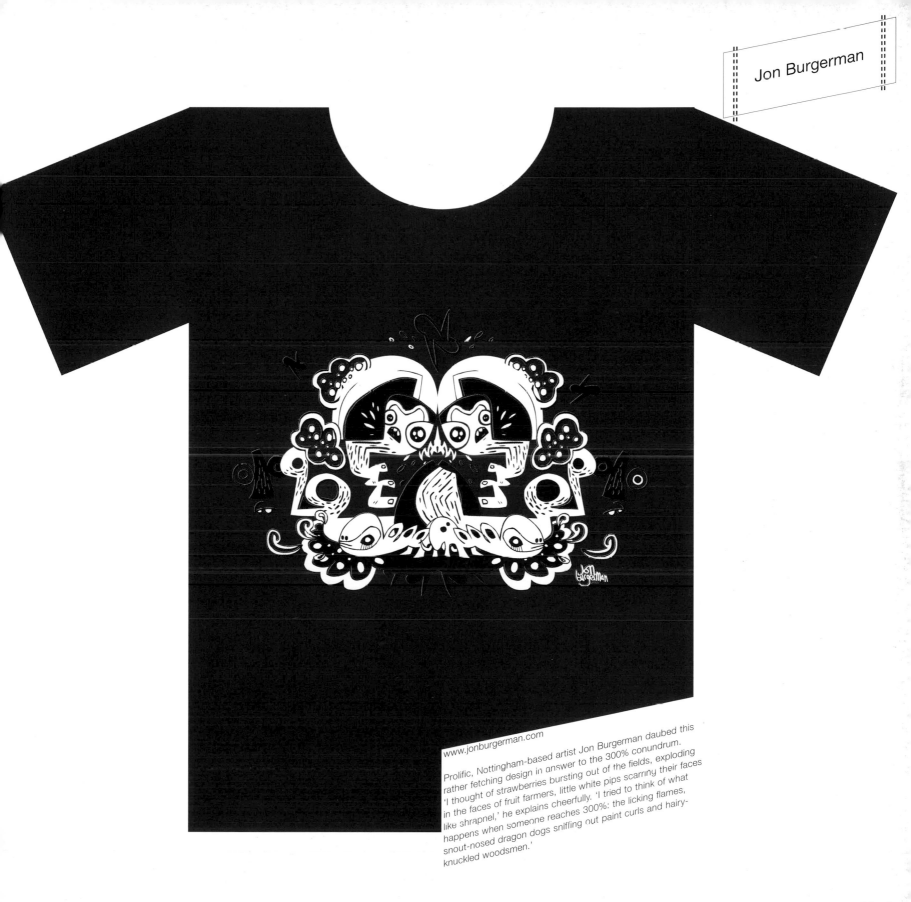

www.jonburgerman.com

Prolific, Nottingham-based artist Jon Burgerman daubed this rather fetching design in answer to the 300% conundrum. 'I thought of strawberries bursting out of the fields, exploding in the faces of fruit farmers, little white pips scarring their faces like shrapnel,' he explains cheerfully. 'I tried to think of what happens when someone reaches 300%: the licking flames, snout-nosed dragon dogs sniffing out paint curls and hairy-knuckled woodsmen.'

flyingbun.com

London-based designer and illustrator Gavin Edwards doesn't buy into the idea of house style: 'I'd rather get a brief and then judge how best to interpret it,' he says. His instincts tend toward the light-hearted and downright loopy. 'I have a sketchbook on me at all times so I can jot things down. Often a small, throwaway sketch will get used because of its spontaneity and incisiveness.' That's what happened in the case of 'The Big Fuzzy Guy', drawn especially for this occasion.

cassspencer.com

Cass Spencer arrived in New York City by way of Newcastle-upon-Tyne and London, UK. Employed as a senior art director at Condé Nast in Manhattan, he previously trained his eye on various high-profile magazines, including Ministry of Sound, Select and Glamour. For this challenge, he went all political on himself and drew a series of bombs of various shapes and sizes, which he then put into a grid of 300. 'Bombs have changed so much over the years,' he explains. 'But there's something so beautiful about them. The simplicity of their aerodynamic form makes an interesting juxtaposition with the horror of what they represent.'

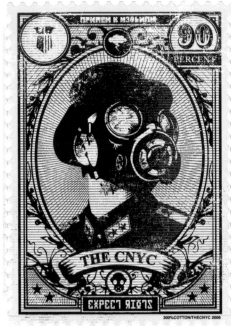
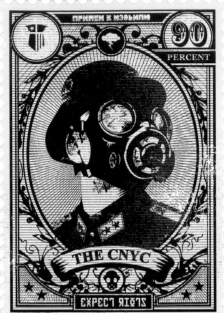

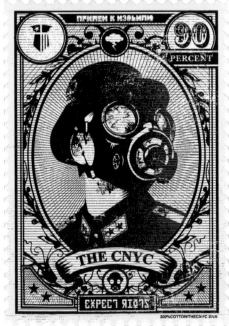
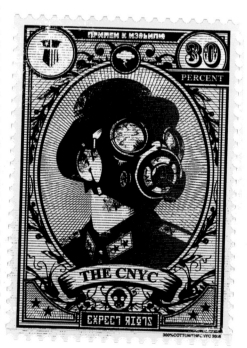

cartelnyc.com

'We sat down and tried to think of various ways to use the 3[...] concept,' explains Lincoln Agnew, freelance designer at [...] CartelNYC and design commissioner of this project. 'Should [...] make 300 of something? Too hard. How about three or four [...] something that add up to 300? Indeed. In the end, we thoug[...] that our chairman, Maximilian, would look great on stamps t[...] add up to 300 percent.' And you know what? They were rig[...]

Now **300%** More Fresh Beef!

FRESH BEEF SIRLOIN CHOPPED
300% MORE

	PACKED ON	SELL BY	WT/LBS.
		FEB 8	1.71

3.29 5.63
TOTAL PRICE

0 201150 305636

SAFE HANDLING INSTRUCTIONS
THIS PRODUCT WAS PREPARED FROM INSPECTED AND PASSED MEAT AND/OR POULTRY. SOME FOOD PRODUCTS MAY CONTAIN BACTERIA THAT COULD CAUSE ILLNESS IF THE PRODUCT IS MISHANDLED OR COOKED IMPROPERLY. FOR YOUR PROTECTION, FOLLOW THESE SAFE HANDLING INSTRUCTIONS.

KEEP REFRIGERATED OR FROZEN. THAW IN REFRIGERATOR OR MICROWAVE

KEEP RAW MEAT AND POULTRY SEPARATE FROM OTHER FOODS. WASH WORKING SURFACES (INCLUDING CUTTING BOARDS), UTENSILS AND HANDS AFTER TOUCHING RAW MEAT OR POULTRY.

COOK THOROUGHLY

KEEP HOT FOODS HOT. REFRIGERATE LEFTOVERS IMMEDIATELY OR DISCARD.

stereotype-design.com

'I wanted to do a T-Shirt design that was in full color—like those 70s tour shirts that you don't see that much these days,' says New York–based Mike Joyce. 'The meat photograph was shot by Michelle Mercurio for a CD single we were working on that never actually materialized. Meanwhile, the term "300%" has such a retail vibe to it that I instantly thought of a supermarket or a meat market. Not many people (including myself) would want to wear this shirt and I kinda like that, too.'

Love

Some people take their love of T-shirts to previously unimagined levels of obsession. Here are some of them.

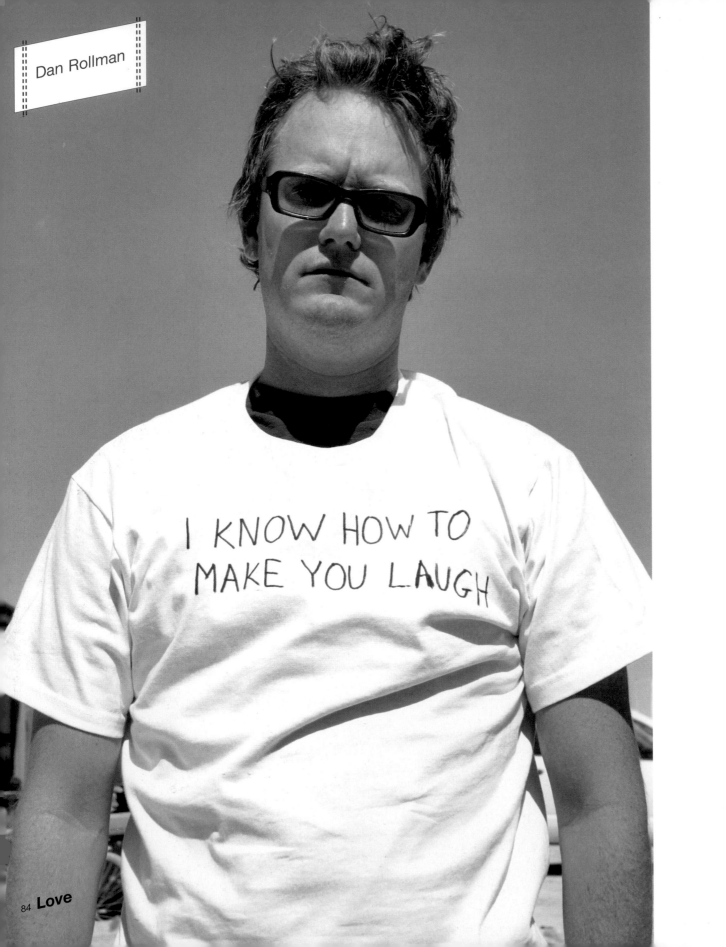

I KNOW HOW TO MAKE YOU LAUGH

OPENING UP SLOWLY

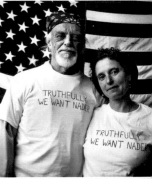

TRUTHFULLY WE WANT NADER

TRUTHFULLY WE WANT NADER

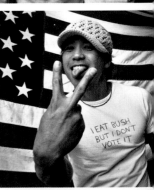

I EAT BUSH BUT I DON'T VOTE IT

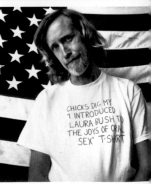

CHICKS DIG MY "I INTRODUCED LAURA BUSH TO THE JOYS OF ORAL SEX" T-SHIRT

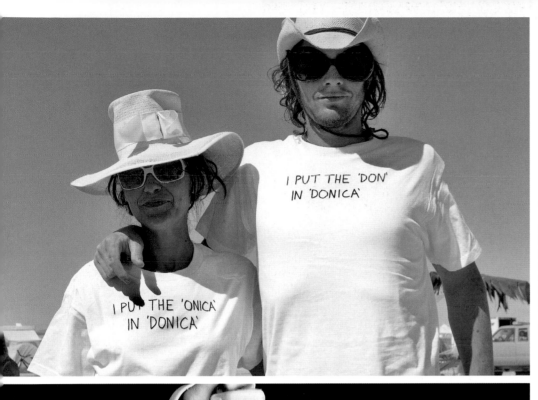

snerko.com

San Francisco–based creative Dan Rollman is an art installation in his own right. His T-shirt project sees him invited to galleries around the world, where he spends opening parties talking to people for a few minutes each. Then he writes an appropriate slogan onto a white T-shirt that he gives to them. Photographer Michael Kennedy shoots the (generally) delighted participants modelling their new top before they trip off into the night. These images serve to document Rollman's ingenious social experiment. Photography: baldkennedy.com

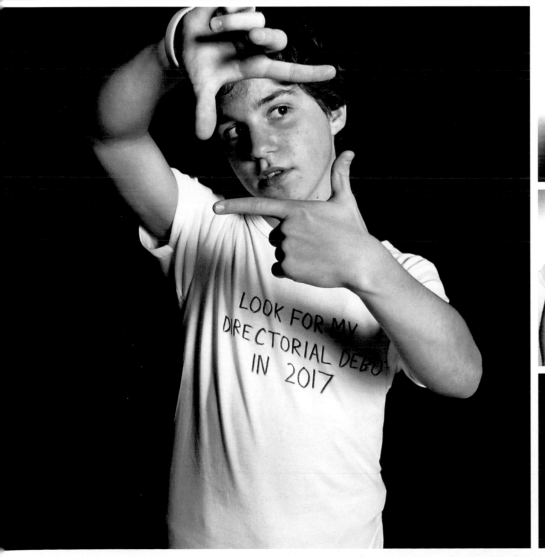

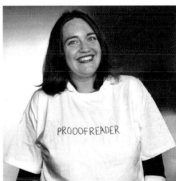

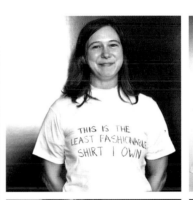

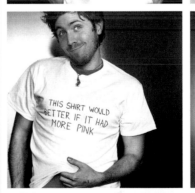

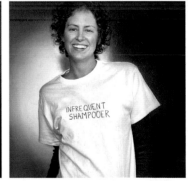

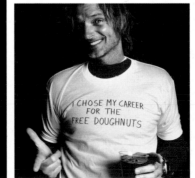

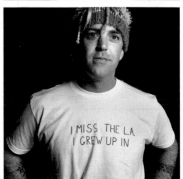

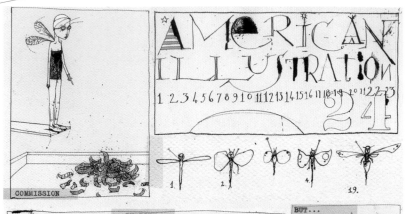

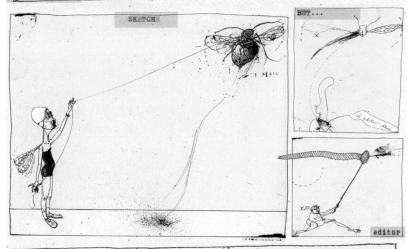

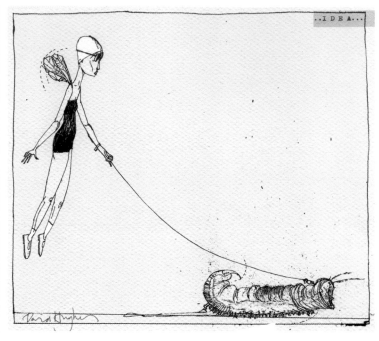

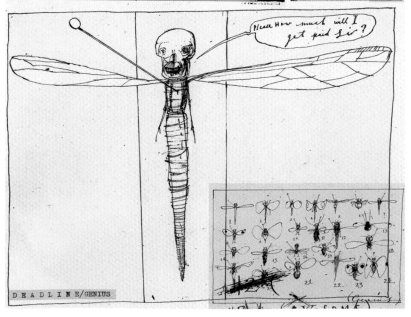

ai-ap.com

Mark Heflin, producer of the prestigious creative annuals American Illustration and American Photography, has access to some of the world's finest artists. He commissioned the ever-amazing British illustrator David Hughes to create a T-shirt promoting the publication of the 24th illustration book. Based on a book cover design by Hannah McCaughey, creative director of Outside magazine, the design is, he says, 'drawn and sarcastic'.

I went all the way to
The End of The World
and all I got was
this lousy T-shirt.

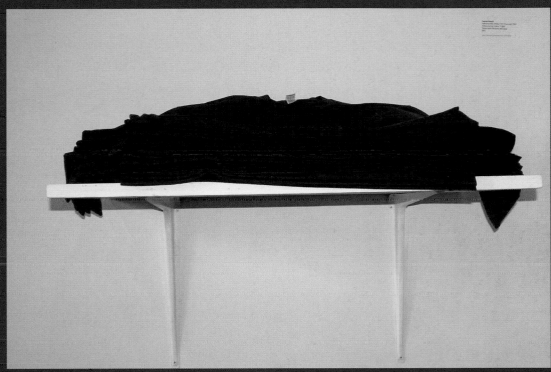

aaronkrach.com

T-shirts were an integral part of an Aaron Krach show, 'The End of the World', held in New York City in the summer of 2005. Featuring video, sculpture, prints, sound, photography and performances at points throughout the exhibition's duration, the gallery space was transformed to display Krach's vision of the concept: a journey to Ushuaia, the world's southernmost city. What else could you possibly want if you made it there but, er, a lousy T-shirt commemorating your journey. 'It's post-post-modern sentimentalism,' says Krach, unrepentantly.

wornby.co.uk

This company rocks. Reproducing iconic images of shirts, you guessed it, worn by such icons as Keith Richards, Ian Dury, Chrissie Hynde and Roger Daltrey, it markets the shirts by showing vintage shots of the originals in action. They pay the original designers for the rights to re-create the imagery – or pay a royalty to charity if unable to locate the artist in question.

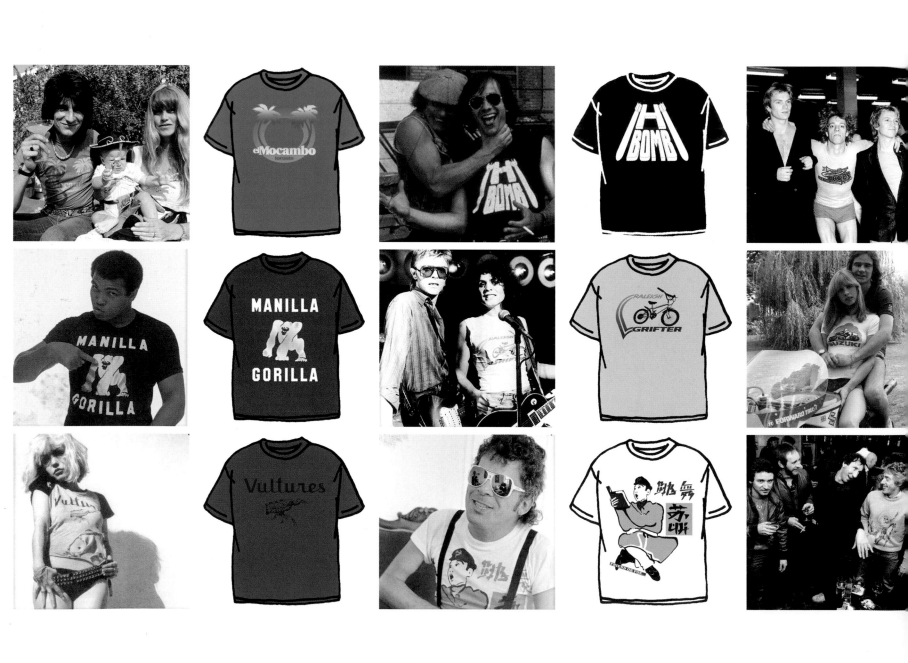

El Mocambo, Chops horns, Suzuki, Ian Dury: photos by Mirrorpix
Manilla: photo by Carl Fischer; source: Sellebrity, George Loiso
Vultures, H Bomb: unknown
Raleigh Grifter: Raleigh
Cowboy: photo by Urban Image
Doctor X, Tom Mix, La Seine, Venice: photos by Rex Features
Jesus Christ: photo by Ray Weaver/Mirrorpix
Pit-bull: photo by Fin Costello/Redferns

LET'S GET IT ON

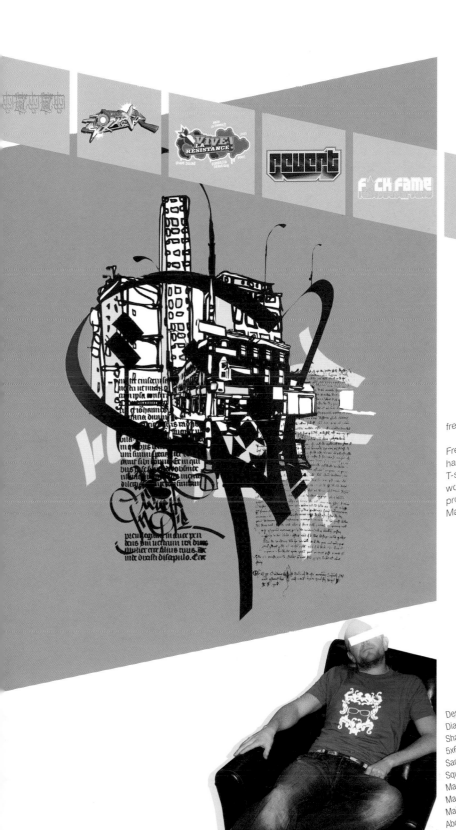

freshcotton.com

Freshcotton.com is one of a number of online companies that has risen up to exploit the ever-growing interest in printed T-shirts. Representing a number of designers from around the world, the Dutch-based company acts rather like an agent, promoting and selling shirts by a roster of artists, including Mambo, Paul Frank and Stussy.

Designs by:
Diagonal line (l–r): Reza (2), HOTEL, U*Faco, Shape Squad, SHOE, Zender, Shape Squad (4), Two Things, Voutloos, Morky
5x6 grid (l–r, top–bottom): ilovedust, Parra, Shape Squad, Olaf Smit, D*Face, Sandder, Parra, D*Face, Two Things, MH, Olaf Smit, HOTEL, Sol Crew, Shape Squad, Machine, Pimpalicious, HOTEL, Shape Squad, ZEDZ, Shape Squad, Machine, Shape Squad, Again, Shape Squad (2), SHOE, Machine, Appelsap, Manonthemoon, Kamer 1
Main, opposite: Olaf Smit
Above left: Two Things
Left: McFaul

AIDS IS A WEAPON OF MASS DESTRUCTION

USE A CONDOM

FAITHLESS

designersagainstaids.com

Ninette Murk, head of the Beauty Without Irony Foundation in Antwerp, launched this project to return the subject of AIDS to the headlines. Her tactic? Asking high-profile designers from various creative disciplines to create a T-shirt graphic highlighting the cause. Designs by: main: Faithless; opposite: Kimiko Yoshida; small images (l–r): The Cardigans, Katharine Hamnett, Spastor, Scissor Sisters, Robert Smith, Christophe Coppens

I USE A CONDOM

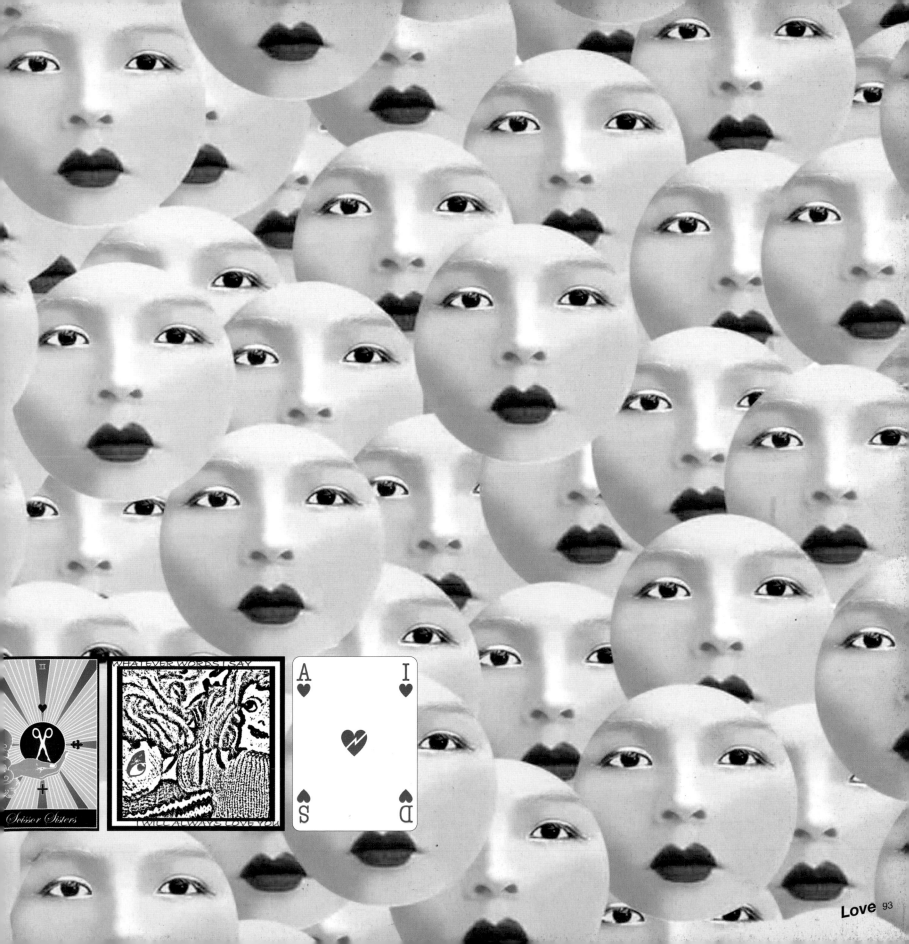

radioactive.com.my

With the intention of promoting Asian design and designers to the world, the T'Styler online competitions were organized by Radioactive, a retail and manufacturing agency based in Selangor, Malaysia. 'We consider the T-shirt a form of canvas for expressing art and design,' explains Jet Law, senior designer at the company. 'A good T-shirt should be high quality with good design, interesting packaging and extra detailing.' Design winners 2005: right: Rukkit Kuanhawate, Thailand (first prize); below: Eko Bintang Prasetya, Indonesia (second prize); below right: Parupon Mukdasanit, Thailand (third prize).

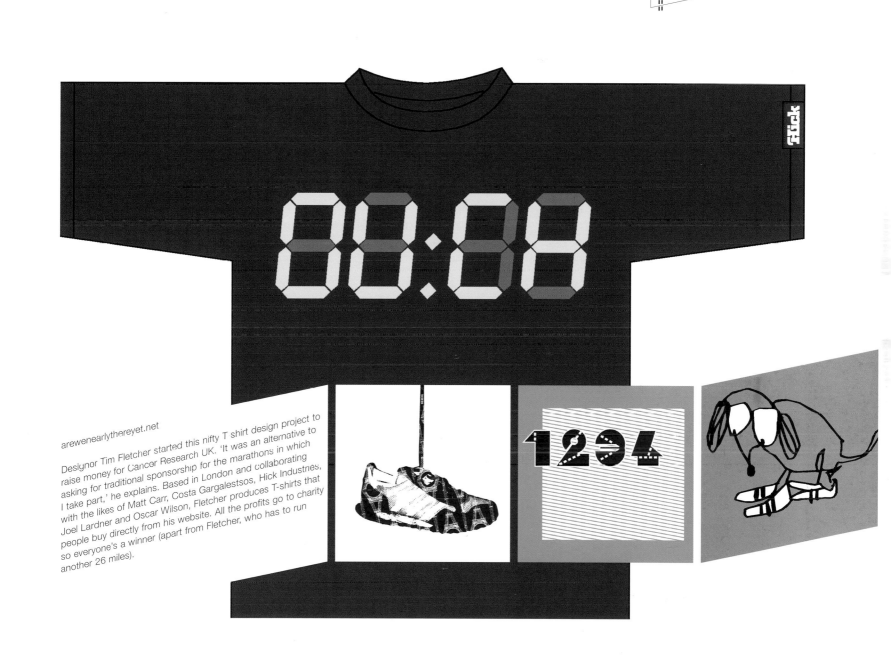

arewenearlythereyet.net

Designer Tim Fletcher started this nifty T shirt design project to raise money for Cancer Research UK. 'It was an alternative to asking for traditional sponsorship for the marathons in which I take part,' he explains. Based in London and collaborating with the likes of Matt Carr, Costa Gargalestsos, Hick Industries, Joel Lardner and Oscar Wilson, Fletcher produces T-shirts that people buy directly from his website. All the profits go to charity so everyone's a winner (apart from Fletcher, who has to run another 26 miles).

1/2 OFF V1AGRA!!

ALERT: YOU ARE BEING WATCHED!

ALERT: YOU ARE BEING WATCHED!

ARE YOU COMING TO THE PARTY?

ARE YOU HARD AT WORK?

100 LETTERS PER SECOND

A QUICK SIMPLE FORM

AMAZING GLORY HOLE ACTION

CONTACT ME ASAP

ARE YOU INTERESTED?

12 DAYS LEFT 'TIL CHRISTMAS!

ADD 3+ INCHES IN WEEKS!

APPEALING TO HOT ONES

BE GOOD

AS REVEALED ON NATIONAL TELEVISION

100 LETTERS PER SECOND

ADV: GET CASH WITH A 4.10% RATE!

BAD CREDIT IS OK

BE PATIENT!

BESTÂÂ S0FTWAREÂÂ

2 + 7 = 11. LET'S CHECK IT... FLATBED

ALL DRUGS LOW PRICE!

AT YOUR PLACE

BE A BETTER LOVER

BEAUTIFUL SLUTS

5 MINUTES LIFETIME SAVINGS

7O% DISC0UNT MED1CATI0NS

ATTACHMENT BLOCKED!

ATTENTION: BRIAN BRUHN

ANTIDOTE FOUND IN CROCODILES

CIALIS, MERIDIA, AMBIEN, XANAX, VALIUM

A MAN IS INCOMPLETE UNTIL HE IS MARRIED

ALERT: EMAIL YOU SENT MAY HAVE A VIRUS

ALL THE BOND GIRLS AND

AMAZING THING I FOUND OUT YESTERDAY

spamshirt.com

Markus Boeniger and Kevin Helas started spamshirt.com to find a use for spam, the scourge of email in-boxes everywhere. Their method and site are brilliantly simple: all you do is select a shirt colour, pick one spam email header from a (very) long list (or write your own), choose a type colour and wait with excitement for your brand new T-shirt to arrive. As they put it, they're 'turning spam into glam'.

EFORE (3),
FTER 6-8
OWN BELOW

BUY CHEAP
VIAGRA
THROUGH US

CHEATING
HOUSE WIFE

DOES YOUR
GIRL LIKE
SURPRISES?

ENHANCE
YOUR LIFE

ETTER SEX
FE

CAN I CALL
YOU?

CHECK THIS
OUT

DON'T MISS
THIS!

EXPERTS
AGREE

IG TIT
ATROL

CAN WE
HANDLE THE
WORK LOAD?

CIALIS #1
RECREATIVE
DRUG

DON'T THINK,
JUST ACT

FAILURE
NOTICE

IGGER
IENER

N_E`ED
M,,ED,S?

DO YOU
MEASURE UP

DRIVE
WOMEN WILD

FAKE

ONNIE WHY
ID YOU SAY
HAT?

CAN'T GO TO
THE BEACH?

DO YOU
REMEMBER
ME?

ENCRYPTED
DOCUMENT

FEEL
AMAZING
OVERNIGHT!

ULLFROG
ETISHISTS
EYOND 942

CAUGHT WITH
A FACE FULL

DO YOU WANT
A ROLEX IN
$75 TO $275?

ENHANCE
YOUR
ANATOMY

FUNNY STUFF

MAZING
EBCAM
IRLS
HOWING IT
LL!

ARE
CREDITORS
HARASSING
YOU?

ARE YOU
SURE YOUR
SITE LISTED
IN GOOGLE?

BE THE 9
INCH MAN
YOUR
GODDESS
CRAVES

CATCH THE
EXP|OSION
FR0M
BREAKING
NEWS

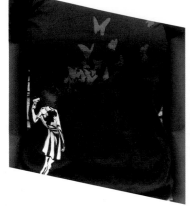
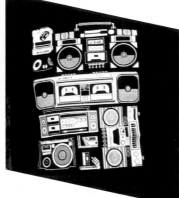
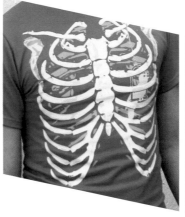
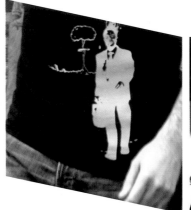

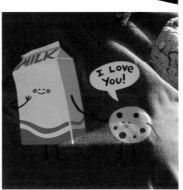

threadless.com

Threadless.com is democracy in progress. The premise is simple: designers upload their ideas for T-shirt graphics to the site. For seven days, viewers can rate the designs and then those with the highest scores go into production. For $200, you can join their 'T-Shirt a Month club', which sends out a limited-edition shirt every month for a year. 'T-shirts never go out of style, and the good ones only get better with age,' says the company's Jake Nickell.

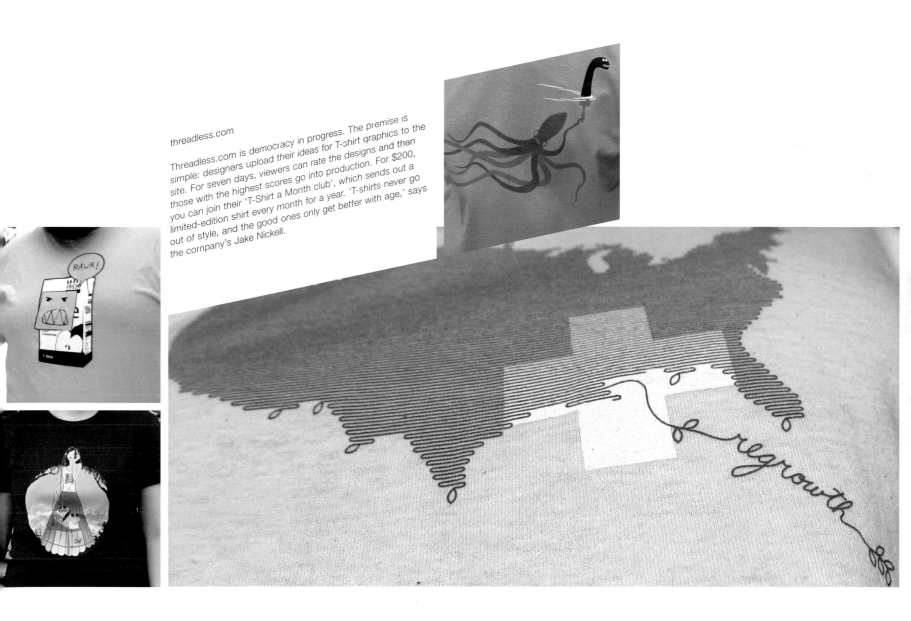

Designs by: clockwise from top left: Jason Byron Nelson, megadan, Frank Barbara, Thomas Chosson, Glenn Jones, Oliver J Moss, Ross Zietz (2), Graye Smith, Guilherme Marconi, Jess Fink, Jun and Dan Gilbert

concretehermit.com

'T-shirts are a medium that everyone understands and feels comfortable with,' says Concrete Hermit founder Chris Knig 'They're clothing, but not fashion; they can carry a message not be "advertising", or they can be "advertising" but not ca a message. There are loads of possibilities to play around w With a personal aesthetic he describes as 'post-neo-old-sk Knight works with various designers to create limited-edition top-quality graphic Ts. Designs by: clockwise, from left: Neasden Control Centre, Mark Taplin, I Like Drawing, Phlash (Phil Ashcroft), Andre Rae, Chris Knight (4)

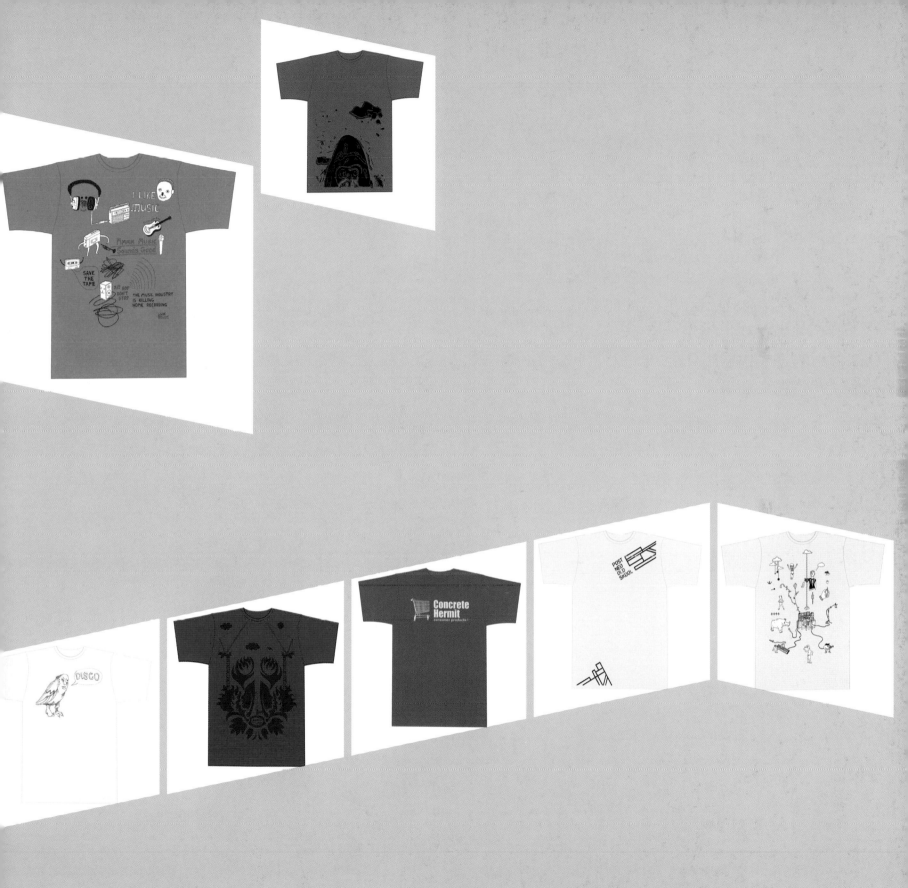

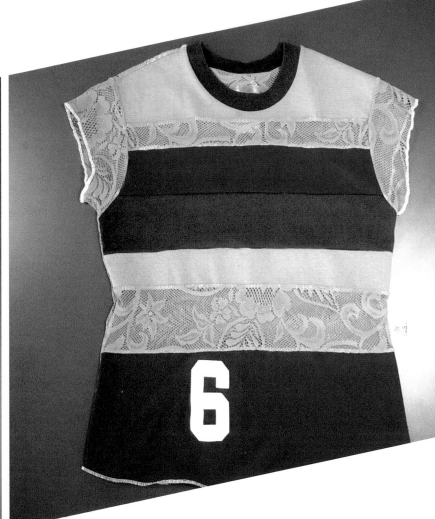

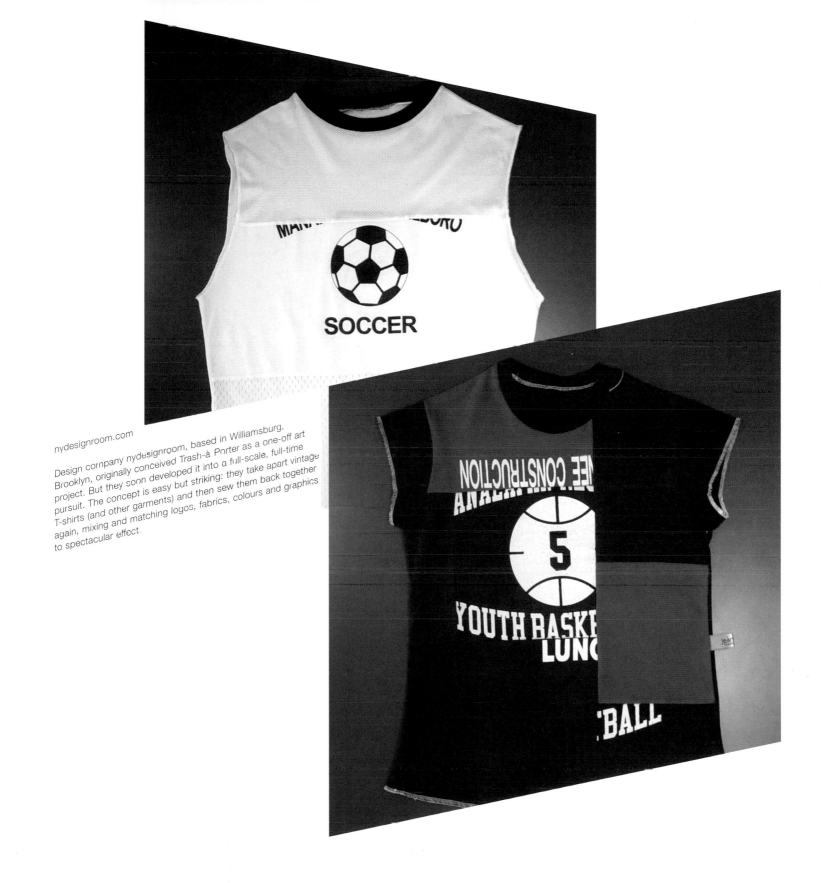

nydesignroom.com

Design company nydesignroom, based in Williamsburg, Brooklyn, originally conceived Trash-à Porter as a one-off art project. But they soon developed it into a full-scale, full-time pursuit. The concept is easy but striking: they take apart vintage T-shirts (and other garments) and then sew them back together again, mixing and matching logos, fabrics, colours and graphics to spectacular effect.

goldmineshithouse.com

Started by David Hochbaum, Travis Lindquist and Colin Burns in early 2003, The Goldmine Shithouse was a way to collaborate on each others' artwork. Then they instituted their irregular but popular T-shirt 'throwdowns', at which guests can get a piece of their clothing customized while supping on beer. 'One of my favorite aspects of the events is their interactive quality,' says Burns. 'I really like the fact that we take clothes that people may already have some connection to and turn them into something else—a souvenir from the party. Hopefully, the article of clothing and the memory of the party will forever be intertwined.' Photography: Keith Coleman

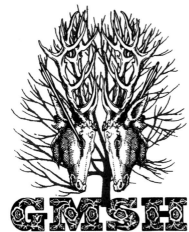

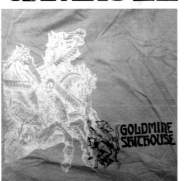

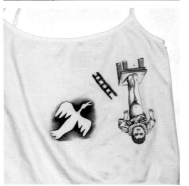

What's on your chest is very persuasive, you know. These designers certainly understand that, and exploit it to the full. But at least by sporting these graphics, you make a cool-looking walking billboard.

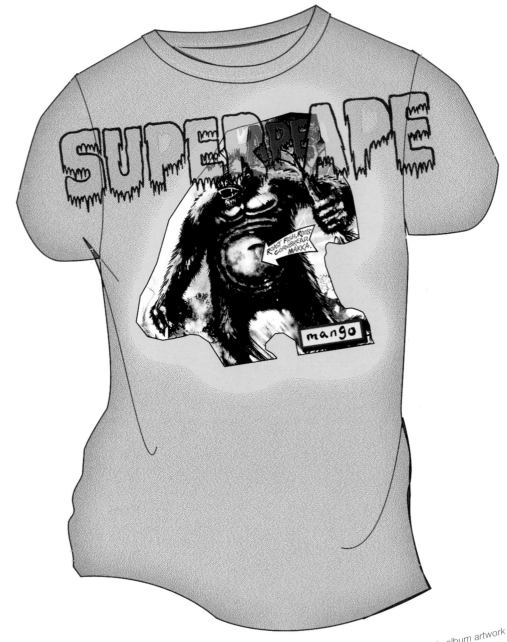

28black.com

London-based agency 28 Black reworks classic album artwork from the legendary Island Records. It's a smart collaboration: the designers get access to fantastic graphics – and the label gets an instant update and a whole new audience. 'We have access to pretty much everything within their back catalogue,' says 28 Black's Aki Paphides. 'Island is cool as long as we stay true and respectful to the genre.'

Nick Holdsworth uses his label, Purple Om, to continue a T-shirt trend begun by Vivienne Westwood and the punk designers of the 70s: using the shirt as a forum for political discussion. For Holdsworth, the effectiveness of a T-shirt entirely depends on its subject matter. 'It's all about taking references from music and popular culture and then distressing or deconstructing them.'

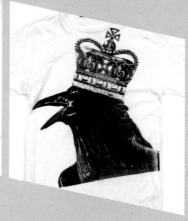

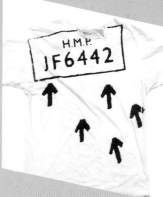

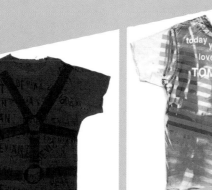

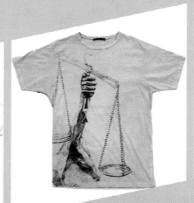

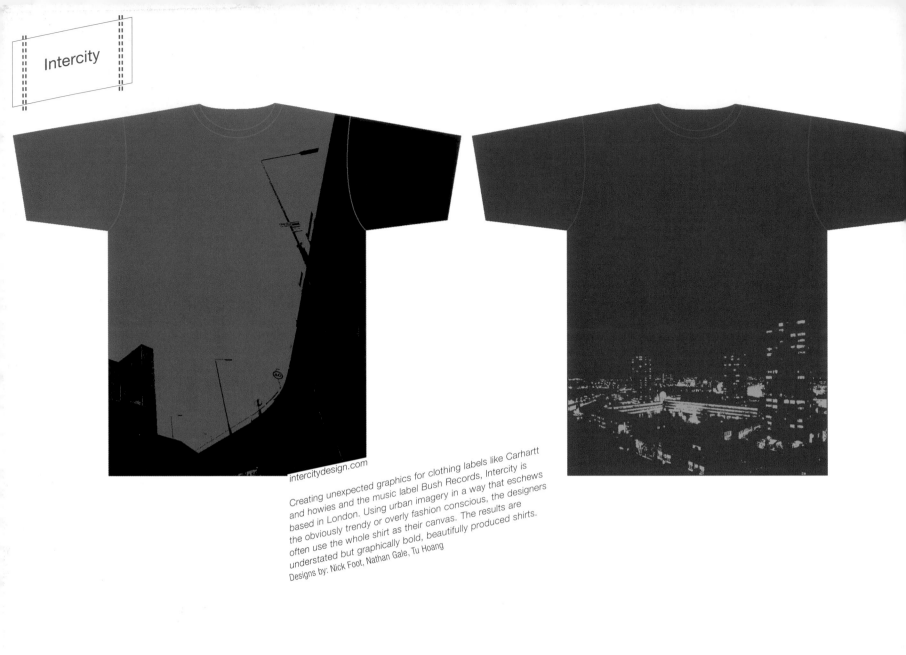

intercitydesign.com

Creating unexpected graphics for clothing labels like Carhartt and howies and the music label Bush Records, Intercity is based in London. Using urban imagery in a way that eschews the obviously trendy or overly fashion conscious, the designers often use the whole shirt as their canvas. The results are understated but graphically bold, beautifully produced shirts.

Designs by: Nick Foot, Nathan Gale, Tu Hoang

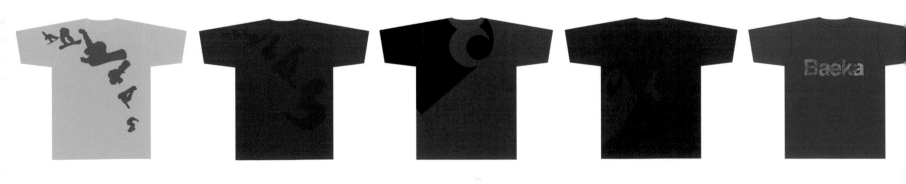

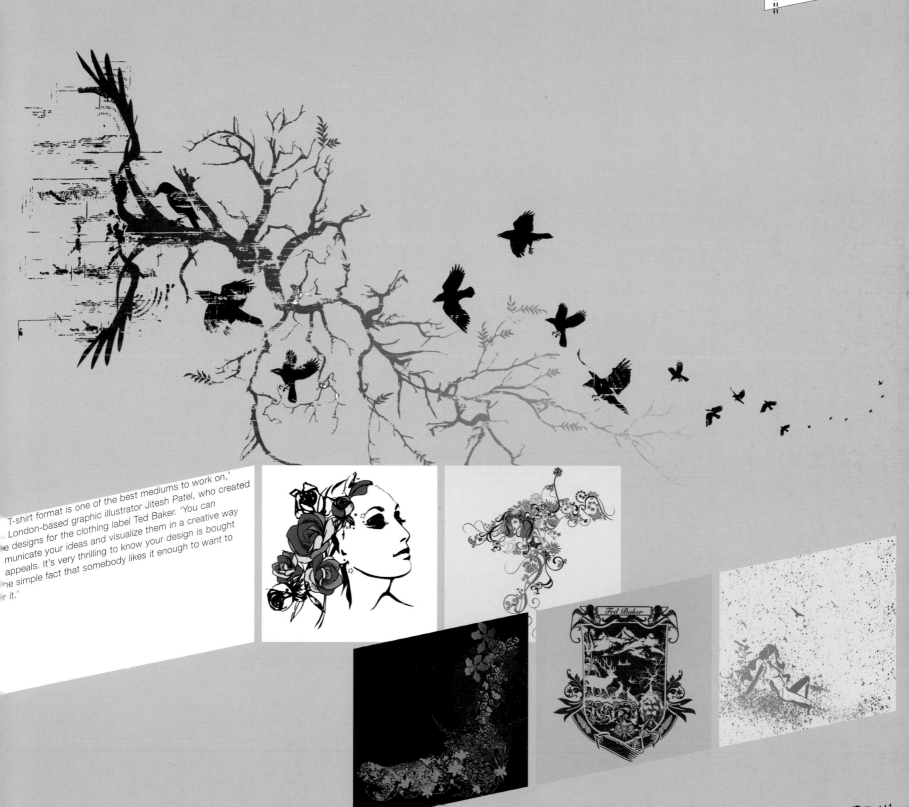

T-shirt format is one of the best mediums to work on,' London-based graphic illustrator Jitesh Patel, who created designs for the clothing label Ted Baker. 'You can municate your ideas and visualize them in a creative way appeals. It's very thrilling to know your design is bought simple fact that somebody likes it enough to want to it.'

Ted Baker

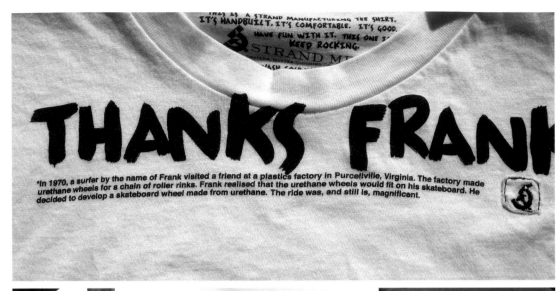

*In 1970, a surfer by the name of Frank visited a friend at a plastics factory in Purcellville, Virginia. The factory made urethane wheels for a chain of roller rinks. Frank realised that the urethane wheels would fit on his skateboard. He decided to develop a skateboard wheel made from urethane. The ride was, and still is, magnificent.

strandmfg.com

'Cotton comfort rules!' says Scott Shandalove of lifestyle clothing company Strand MFG. 'A good T-shirt will be one part subtle, one part interesting, two parts clever and funny,' adds Mark 'Fank' Fankhauser, who works on the design of the label's shirts. With offices in both Los Angeles and Seattle, the company's aesthetic is deeply immersed in skateboard subculture. Their motto, according to Shandalove, is the warm and friendly, 'Come skate with us'.

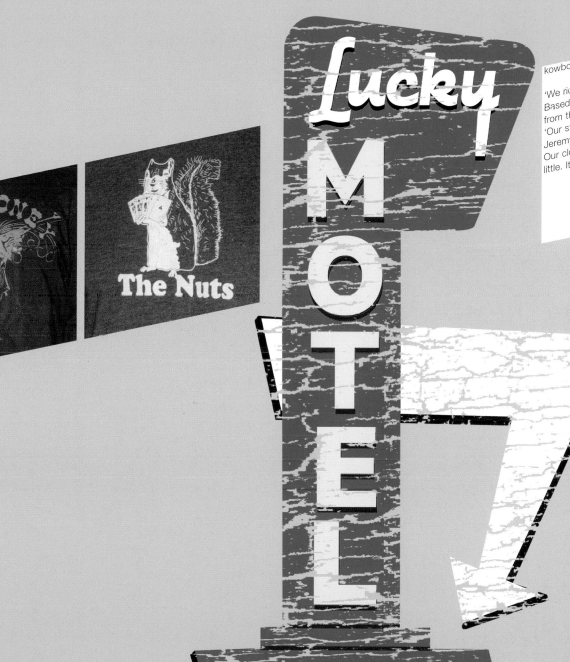

The Nuts

Lucky MOTEL 7

No VACANCY

kowboys.not

'We ride hard and play harder,' says Mitchell Rose of Kowboys. Based in Hollywood, California, their T-shirts often take images from their surroundings to convey a vintage, laid-back feel. 'Our style is Las Vegas meets the streets of Old Havana,' adds Jeremy Joseph. 'Ketel on the rocks with a shot of Rye attitude. Our clothes are comfortable, feel good and say a lot by saying little. It's an upscale style on the down low.'

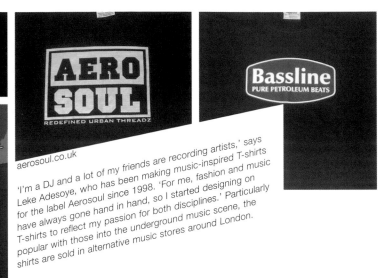

aerosoul.co.uk

'I'm a DJ and a lot of my friends are recording artists,' says Leke Adesoye, who has been making music-inspired T-shirts for the label Aerosoul since 1998. 'For me, fashion and music have always gone hand in hand, so I started designing on T-shirts to reflect my passion for both disciplines.' Particularly popular with those into the underground music scene, the shirts are sold in alternative music stores around London.

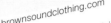

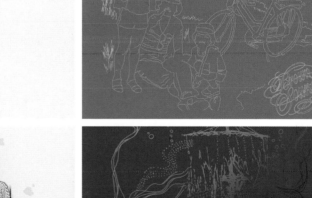

brownsoundclothing.com

Los Angelenos Rob Sinclair and Charlie Staunton started their clothing company in the spring of 2002. There's more to the company than T-shirts, but graphically printed shirts form an integral part of each collection. 'We see our T-shirts as a voice for the collection,' says Sinclair, who describes their style as 'naive modern folk'. Staunton adds, 'A good T-shirt graphic needs no explanation. It should take you on a life-changing adventure through hills and valleys.'

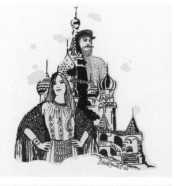

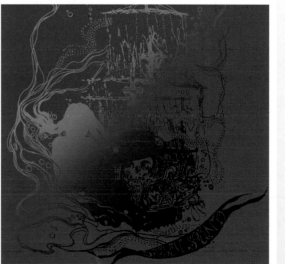

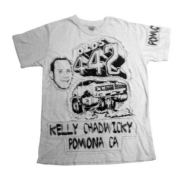
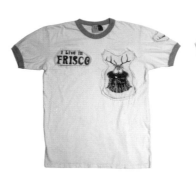
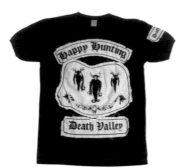
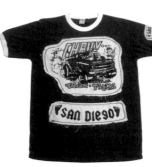

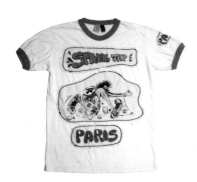
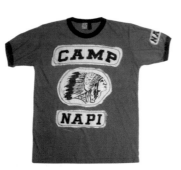
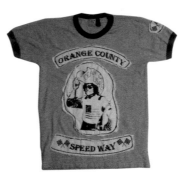
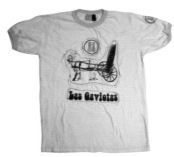
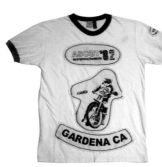

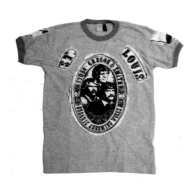
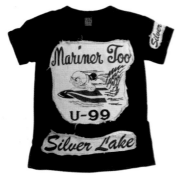
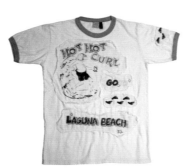
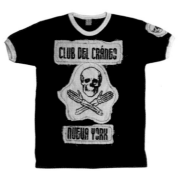
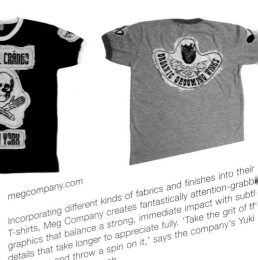

megcompany.com

Incorporating different kinds of fabrics and finishes into their T-shirts, Meg Company creates fantastically attention-grabbi[ng] graphics that balance a strong, immediate impact with subtl[e] details that take longer to appreciate fully. 'Take the grit of th[e] status quo and throw a spin on it,' says the company's Yuki Matsuda of their approach.

redclaydesigns.com

It's always nice to soe 80s icons making a comeback. Here Miami Vice's very own Crockett and Tubbs play a starring role on a T-shirt from design firm Red Clay, based in Oakland, California. 'I like to print eye-catching graphics and colors that evoke feeling and thought,' explains the label's Adamu Chan. 'T-shirts give you more freedom in terms of graphic expression than any other kind of garment.'

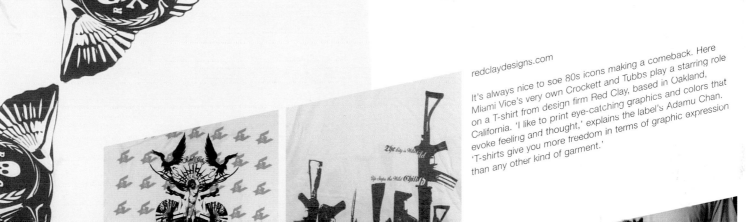

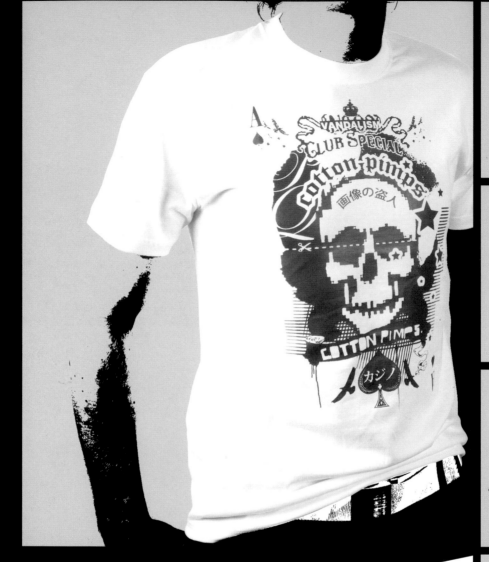

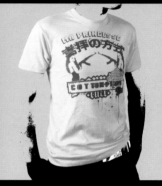

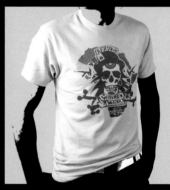

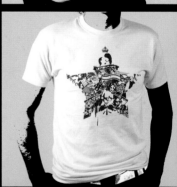

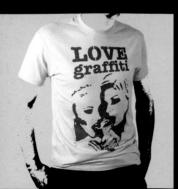

cottonpimps.com

'If you ain't got the balls, don't go looking for a "pimp"!' says Mark Wilkinson of the Manchester label he started in 2005. 'T-shirts are a great mobile canvas for my illustrations and thoughts: they can spread like a virus wherever the body takes them, whereas a painting is fixed to a gallery wall.' As for his style? 'It's an independent, outlandish, outrageous fusion of found, stolen, cut 'n' shut images, inspired by the Internet, electro, punk, street art and porn. It's chaotic yet organized.'

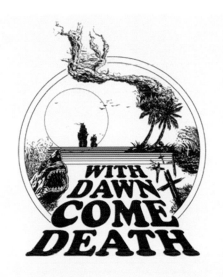

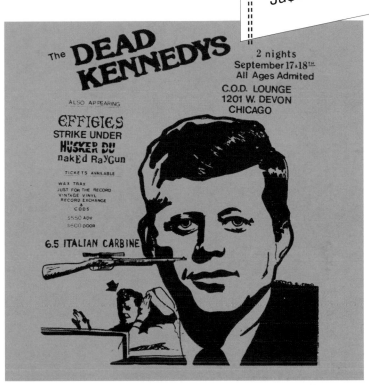

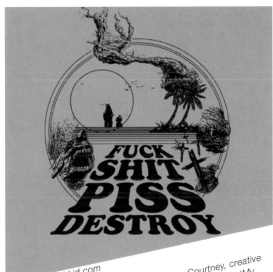

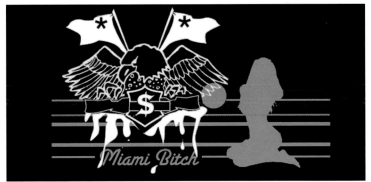

justanotherrichkid.com

'85% of my wardrobe is T-shirts,' says Ken Courtney, creative director of the willfully avant-garde menswear company. 'My designs appeal to people who want to separate themselves from the pack. The shirts are fitted and look great, but the color combinations and graphics are always a bit on the edge.'

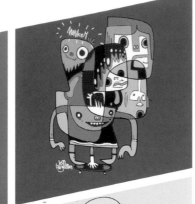

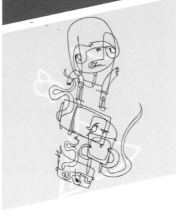

jonburgerman.com

A 'doodle-artist', Nottingham-based Jon Burgerman considers the T-shirt the perfect format for wearing his own work. His detailed, whimsical illustrations are colourful and cute. Or, as he puts it, he creates 'looping, interconnecting, incessant, continuous lines with added colour'. As for his audience? 'Lucky, lucky, smart, good-looking, intelligent people with an eye for quality,' he says. 'Bless each and every one of them.'

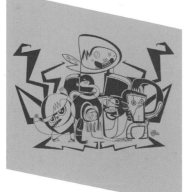
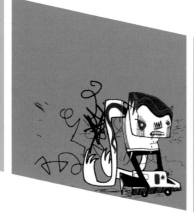

Super snot zombie.

Special Friends

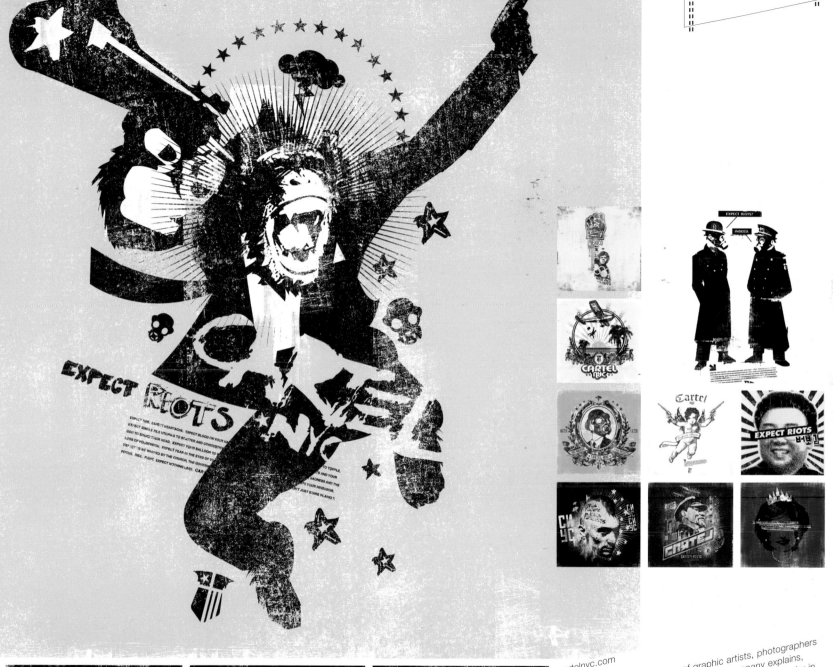

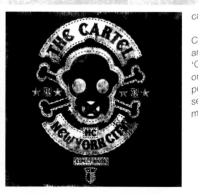

cartelnyc.com

Comprising a shadowy group of graphic artists, photographers and writers, the New York-based design company explains, 'Our conceptual vision is to examine worldwide iconography in order to understand and perhaps undermine the mythology of power. By deconstructing these images and inserting our own sense of humor and twisted wit we create the designs that make up the brand.'

CRIMINAL HISTORY SHEET

5/17 U/U 000/000 23/17

Date........ 4th February, 1975.

75-138/78 Gaol Photo 75-138/83:
...51 Photo 5197 (71):Gaol Photo 75/130/75 VSP.376/77 VSP.46/78

R.720 Docket No........ 3337/74 Gaol No........ CRN 3403

7.11.1954. Record of Convictions against DEAD: Mark Brendon.

Mark Brandon Read. @ "CHOPPER" "THE MARK".

"TO THE HUMAN FILTH

I HAVE BASHED, BELTED, IRON BARRED, AXED, SHOT, STABBED, KNEE CAPPED, SET ON FIRE AND DRIVEN TO THEIR GRAVES...

I REGRET NOTHING"

VICTORIA POLICE

Court		Date			Offence	Sentence
C.C.	18	5	71		Attempted storeroom break & steal	Admitted to S.W.B. as Mark Brendon Read.
M.C.	20	12	71		Assault by kicking. Unlawful assault (2 charges).	1 month on each charge.
					Indecent language.	$10 def, 2 days. as Mark Brandon Read.
M.C.	24	3	74		Armed with offensive weapon.	1 month. as Mark Brendon Read.
M.C.	26	11	74		Indecent language. Assault Police (2 charges).	$50 def. distress. 1st charge Adjourned for 2 years on a $50 G.B. Bond. 2nd charge Struck Out. as Mark Brandon Read.
.C.	18	4	75		Burglary. Assault. Impersonate police.	6 months. 2 months on each charge concurrent & concurrent with 1st charge.as Mark Brandon Read.
	1	5	75		Burglary with intent to commit assault occasioning actual bodily ...	Acquitted by direct...
	11	2	76			
	1	12	75		...ion. Possess articles not issu...	
M.C.	31	5	77			

PLEAD
GUILTY

CHOPPER

Mark Brandon Chopper Read

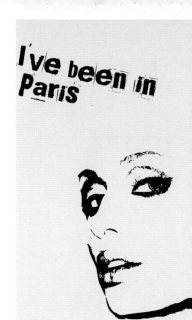

I've been in Paris

✳ SIDE EFFECTS MAY INCLUDE

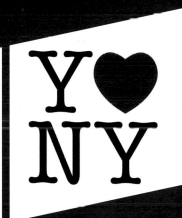

ABNORMAL DREAD OR FEAR • ACHINESS • BLEEDING IN THE STOMACH AND/OR INTESTINES • BLOOD CLOTS IN THE LUNGS • BLURRED VISION • BREAST PAIN • CHANGE IN COLOR PERCEPTION • CHILLS • CONFUSION • CONSTIPATION • CONVULSIONS • COUGHING UP BLOOD • DECREASED VISION • DEPRESSION • DIARRHEA • DIFFICULTY IN SWALLOWING • DISCOMFORT • DIZZINESS • DOUBLE VISION • DROWSINESS • EYE PAIN • FAINTING • FEVER • FLUSHING • FOOT PAIN • GAS • GOUT FLARE UP • HALLUCINATIONS • HEADACHE • HEARING LOSS • HEART ATTACK • HICCUPS • HIGH BLOOD PRESSURE • HIVES • INABILITY TO FALL OR STAY ASLEEP • INABILITY TO URINATE • INDIGESTION • INTESTINAL INFLAMMATION • INVOLUNTARY EYE MOVEMENT • IRREGULAR HEARTBEAT • IRRITABILITY • ITCHING • JOINT OR BACK

PAIN • JOINT STIFFNESS • KIDNEY FAILURE • LABORED BREATHING • LACK OF MUSCLE COORDINATION • LACK OR LOSS OF APPETITE • LARGE VOLUMES OF URINE • LIGHT HEADEDNESS • LOSS OF SENSE OF IDENTITY • LOSS OF SENSE OF SMELL • MOUTHSORES • NAUSEA • NECK PAIN • NIGHTMARES • NOSEBLEED • POUNDING HEARTBEAT • RASH • REDNESS • RESTLESSNESS • RINGING IN THE EARS • SEIZURES • SENSITIVITY TO LIGHT • SEVERE ALLERGIC REACTION • SKIN PEELING • SLUGGISHNESS • SPEECH DIFFICULTIES • SWELLING OF THE FACE NECK LIPS EYES OR HANDS • SWELLING OF THE THROAT • SWOLLEN LYMPH NODES • TENDER RED BUMPS ON SKIN • TINGLING SENSATION • TREMORS • UNPLEASANT TASTE • UNUSUAL DARKENING OF THE SKIN • INFLAMED VAGINA • VAGUE FEELING OF ILLNESS • VOMITING • WEAKNESS • YELLOWED EYES AND SKIN

headlineshirts.net

'We use the interplay of ink and shirt, including translucent inks and designs that exploit the colors of both the shirt and the ink. We also consider the way a shirt curves around a body,' says Chris Gorog, president of the San Francisco–based company. Their bold designs are often provocative but somehow quintessentially American.

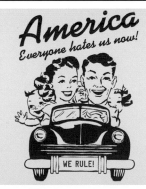

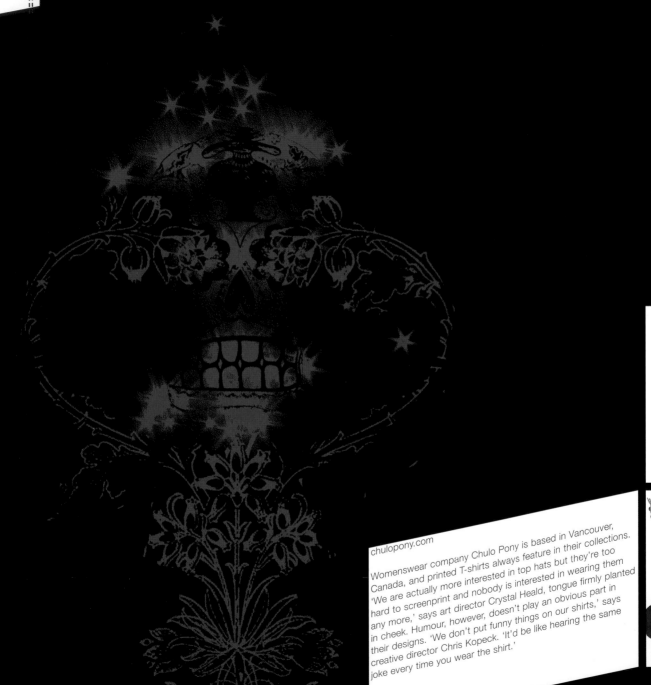

chulopony.com

Womenswear company Chulo Pony is based in Vancouver, Canada, and printed T-shirts always feature in their collections. 'We are actually more interested in top hats but they're too hard to screenprint and nobody is interested in wearing them any more,' says art director Crystal Heald, tongue firmly planted in cheek. Humour, however, doesn't play an obvious part in their designs. 'We don't put funny things on our shirts,' says creative director Chris Kopeck. 'It'd be like hearing the same joke every time you wear the shirt.'

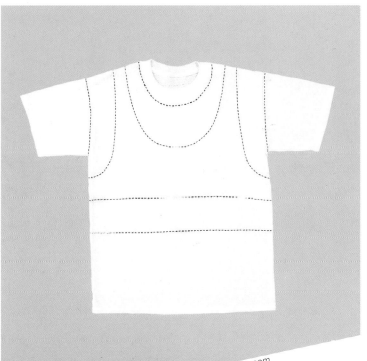

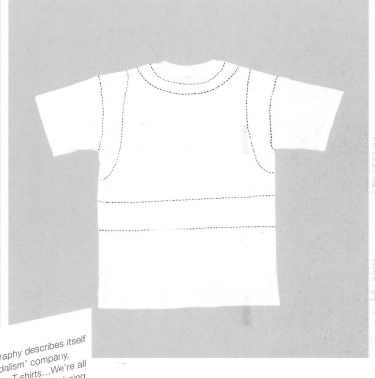

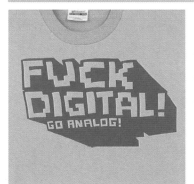

posttypography.com

Based in Baltimore, Maryland, Post Typography describes itself as a 'graphic design, printmaking and vandalism' company. Designer Bruce Willen says, 'We like to wear T-shirts…We're all about "casual Fridays". Our shirts are conceptual without being boring; stupid without being dumb and both hard to look at and pretty.'

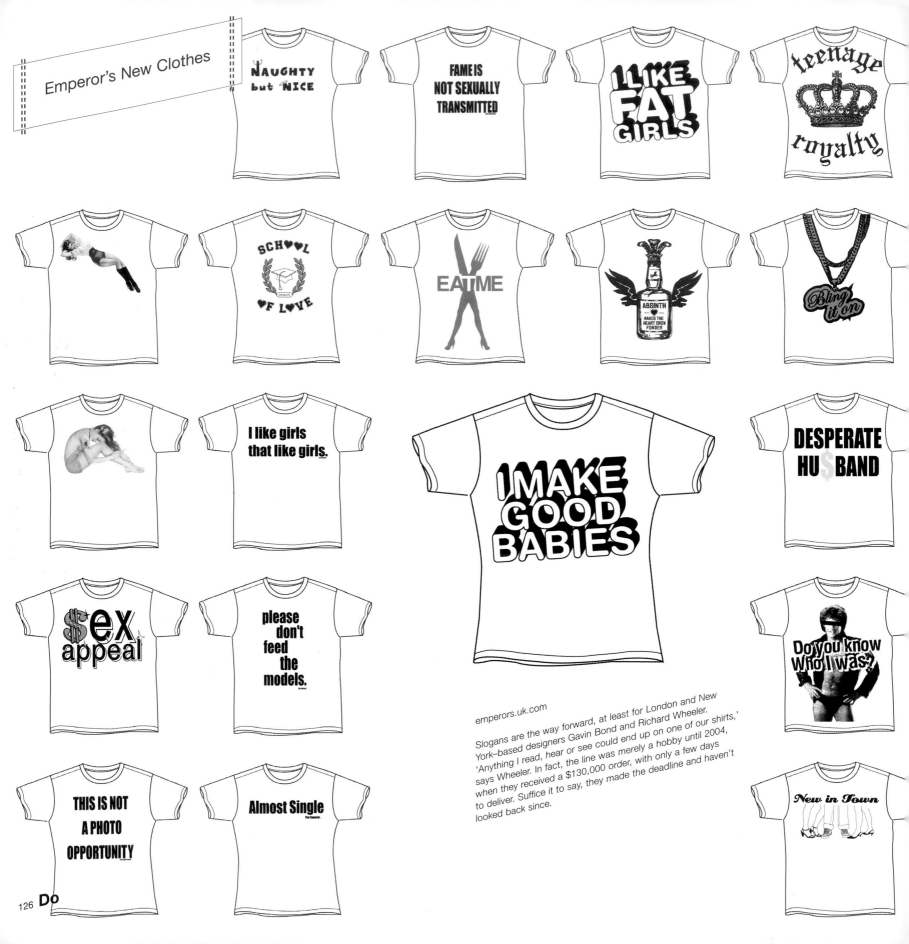

NAUGHTY but NICE

FAME IS NOT SEXUALLY TRANSMITTED

I LIKE FAT GIRLS

teenage royalty

SCHOOL OF LOVE

EAT ME

ABSINTH MAKES THE HEART GROW FONDER

Bling it on

I like girls that like girls.

I MAKE GOOD BABIES

DESPERATE HU$BAND

$ex appeal

please don't feed the models.

Do you know who I was?

emperors.uk.com

Slogans are the way forward, at least for London and New York–based designers Gavin Bond and Richard Wheeler. 'Anything I read, hear or see could end up on one of our shirts,' says Wheeler. In fact, the line was merely a hobby until 2004, when they received a $130,000 order, with only a few days to deliver. Suffice it to say, they made the deadline and haven't looked back since.

THIS IS NOT A PHOTO OPPORTUNITY

Almost Single

New in Town

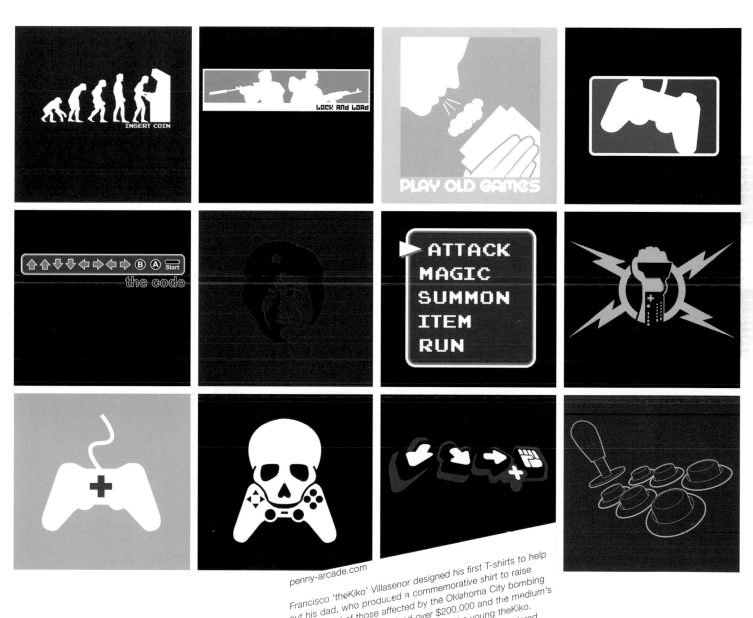

penny-arcade.com

Francisco 'theKiko' Villasenor designed his first T-shirts to help out his dad, who produced a commemorative shirt to raise money in aid of those affected by the Oklahoma City bombing in 1995. The campaign raised over $200,000 and the medium's effectiveness was neatly emphasized to the young theKiko. As for these retro-inspired shirts: 'In the late 90s I wondered why there were no clothing designs targeting video-game players,' he explains. So he took it upon himself to redress the balance.

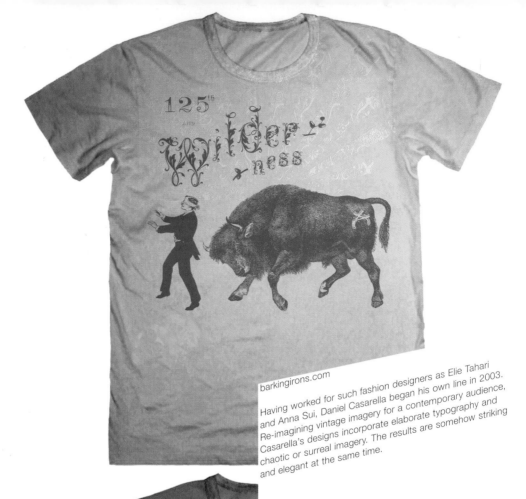

barkingirons.com

Having worked for such fashion designers as Elie Tahari and Anna Sui, Daniel Casarella began his own line in 2003. Re-imagining vintage imagery for a contemporary audience, Casarella's designs incorporate elaborate typography and chaotic or surreal imagery. The results are somehow striking and elegant at the same time.

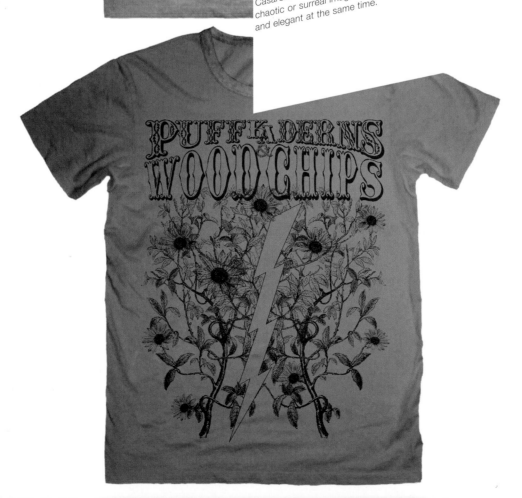

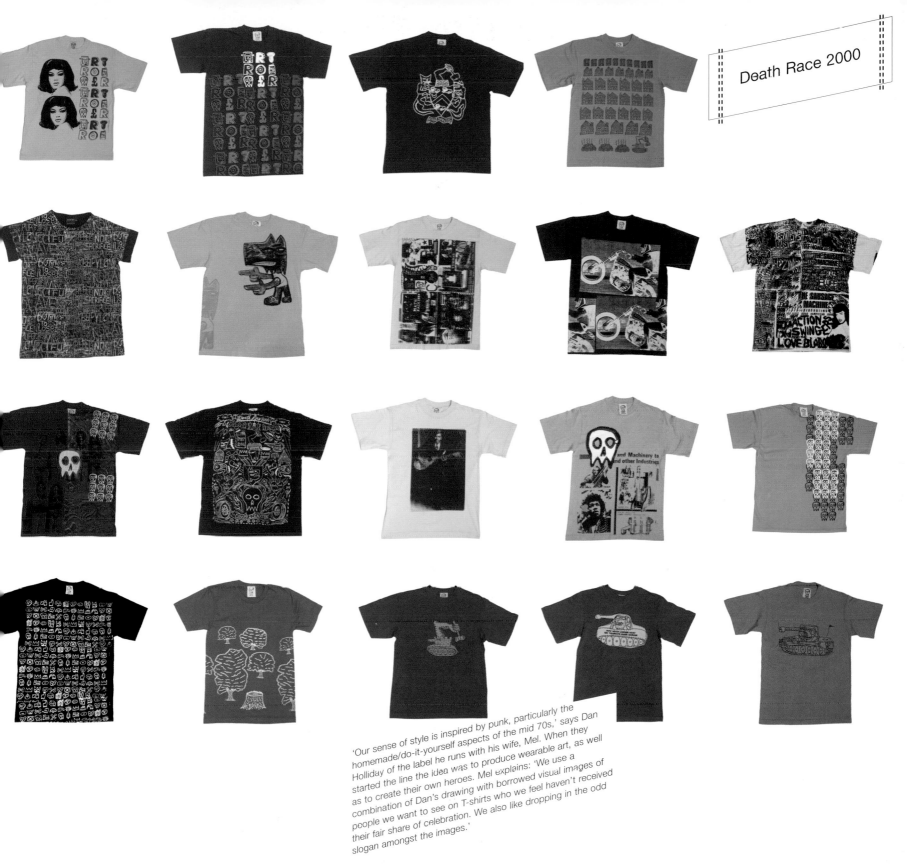

'Our sense of style is inspired by punk, particularly the homemade/do-it-yourself aspects of the mid 70s,' says Dan Holliday of the label he runs with his wife, Mel. When they started the line the idea was to produce wearable art, as well as to create their own heroes. Mel explains: 'We use a combination of Dan's drawing with borrowed visual images of people we want to see on T-shirts who we feel haven't received their fair share of celebration. We also like dropping in the odd slogan amongst the images.'

cocorico

quack quac

wang wang

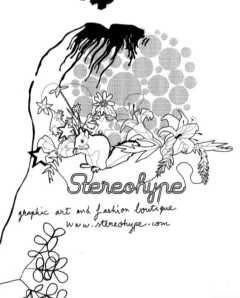

Stereohype

graphic art and fashion boutique
www.stereohype.com

stereohype.com

Founded by the designers of this very book, Tomi Vollauschek and Agathe Jacquillat, stereohype.com is an online boutique offering limited-edition products designed by the pair and other emerging and established artists. Their own designs show their love of whimsical, charming imagery, and their most recent collection includes a range for babies and children, as well as more tailored clothing to go along with their perennially popular printed T-shirts.

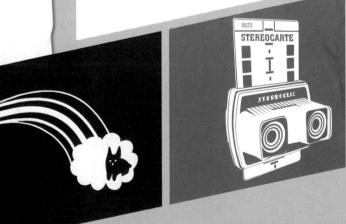

kanabeach

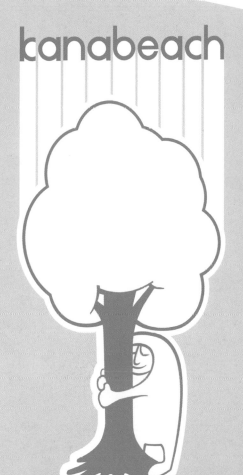

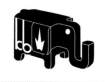

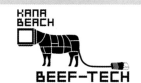

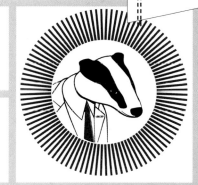

kanabeach.com

Eric Delvoye is the designer at Kanabeach, a surfwear and fashion label based in Brittany, France. Light-hearted, simple but strong graphics abound throughout the range. 'I aim for an elegant blend of good colours and good vibes,' explains Delvoye. 'It's "soopa" style for those that dig.'

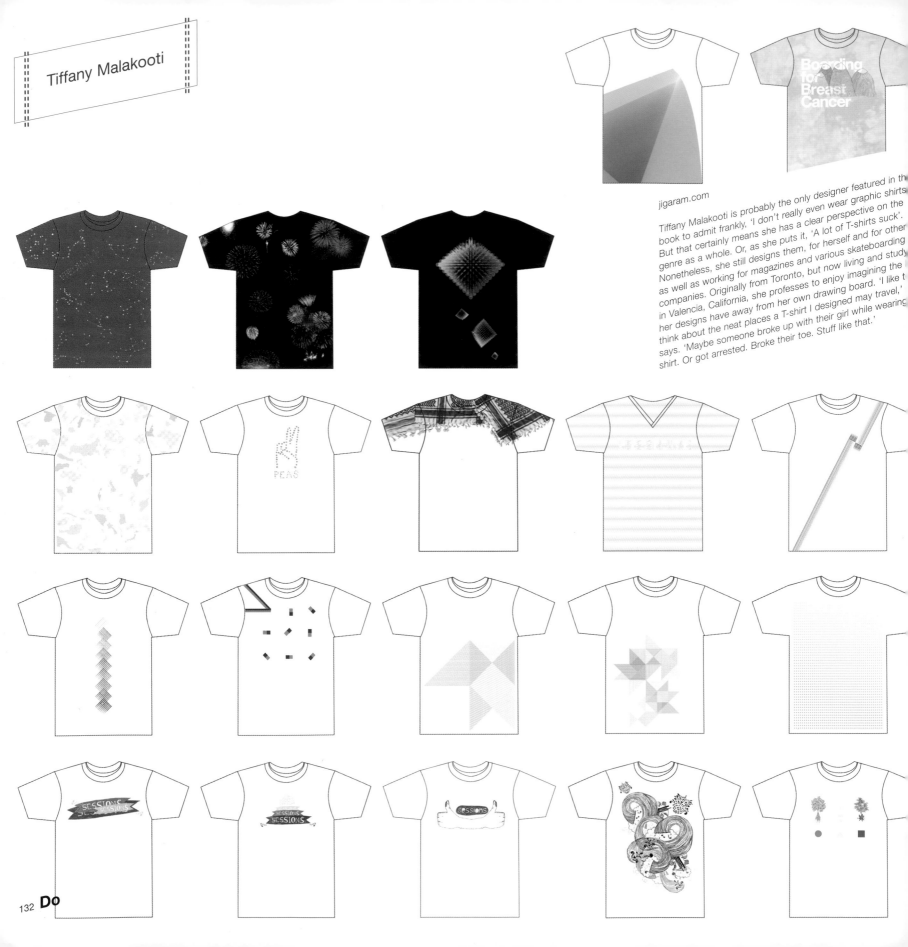

Tiffany Malakooti

jigaram.com

Tiffany Malakooti is probably the only designer featured in th... book to admit frankly, 'I don't really even wear graphic shirts... But that certainly means she has a clear perspective on the... genre as a whole. Or, as she puts it, 'A lot of T-shirts suck'. Nonetheless, she still designs them, for herself and for other... as well as working for magazines and various skateboarding... companies. Originally from Toronto, but now living and study... in Valencia, California, she professes to enjoy imagining the t... her designs have away from her own drawing board. 'I like t... think about the neat places a T-shirt I designed may travel,'... says. 'Maybe someone broke up with their girl while wearing... shirt. Or got arrested. Broke their toe. Stuff like that.'

junkfunk.com

Inspired by trash, popular and social culture, Huw Williams is the designer for London clothing label Junkfunk. 'An undercurrent of irreverent British humour runs through many of the designs,' he says. Williams sees shirts, which he sells at Portobello Road Market, as an opportunity to experiment graphically and as an ideal way to avoid the constraints of more traditional, commercial projects.

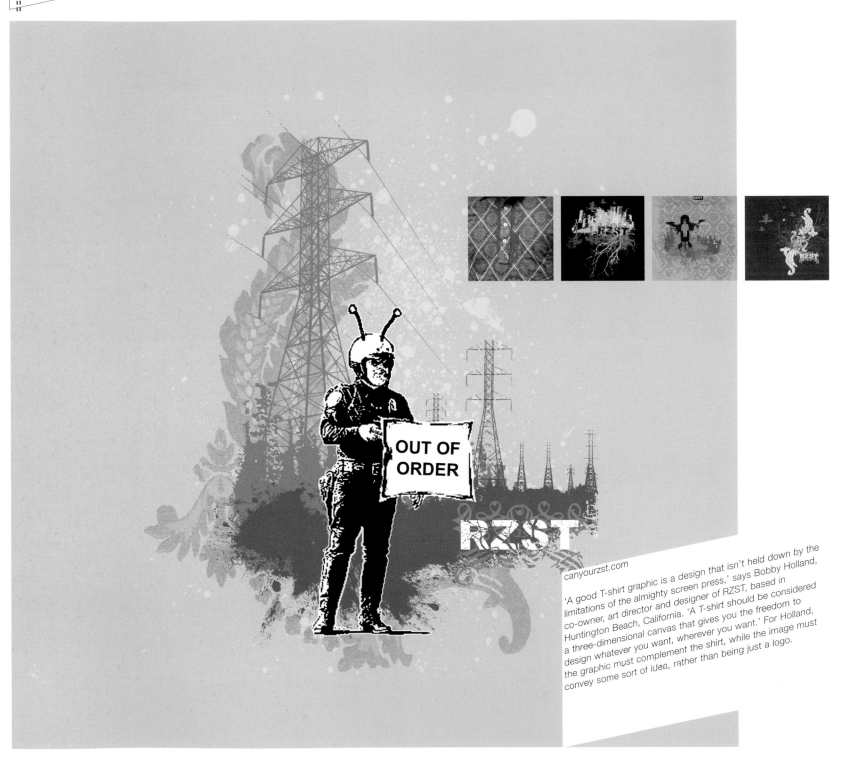

OUT OF
ORDER

RZST

canyourzst.com

'A good T-shirt graphic is a design that isn't held down by the limitations of the almighty screen press,' says Bobby Holland, co-owner, art director and designer of RZST, based in Huntington Beach, California. 'A T-shirt should be considered a three-dimensional canvas that gives you the freedom to design whatever you want, wherever you want.' For Holland, the graphic must complement the shirt, while the image must convey some sort of idea, rather than being just a logo.

jawa-midwich.com

London-based designers Jawa and Midwich began collaborating with commercials and promo director Emma on a T-shirt line in April 2005. 'It was another way to distribute visual ideas,' they explain. 'To work with Emma, jamming out designs was interesting and creative – and we got sweet T-shirts out of it, too!' They describe their style as a balance of simple and detailed, striking and intricate.

nostarclothing.com

'They're cooler than bumper stickers,' says Erik Prowell of T-shirts. The company, based in Portland, Oregon, produces simple but attention-grabbing graphics that are invariably hilarious. Their 'mustache/gun' shirt, for instance, is so wrong, it's really very right.

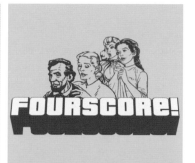

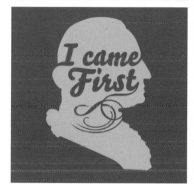

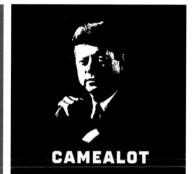

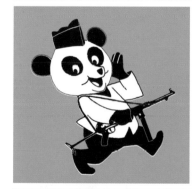

sharpastoast.com

Toast may not be that sharp in real life, but this company, working out of Winnetka, Illinois, specializes in producing shirts that include pointed political messages. 'We wanted to provoke an interest in US politics and history in young people, to inspire them to vote in elections,' says Jimm Lasser, president of the company. For Lasser, T-shirts are an ideal way to communicate with this politically apathetic demographic.

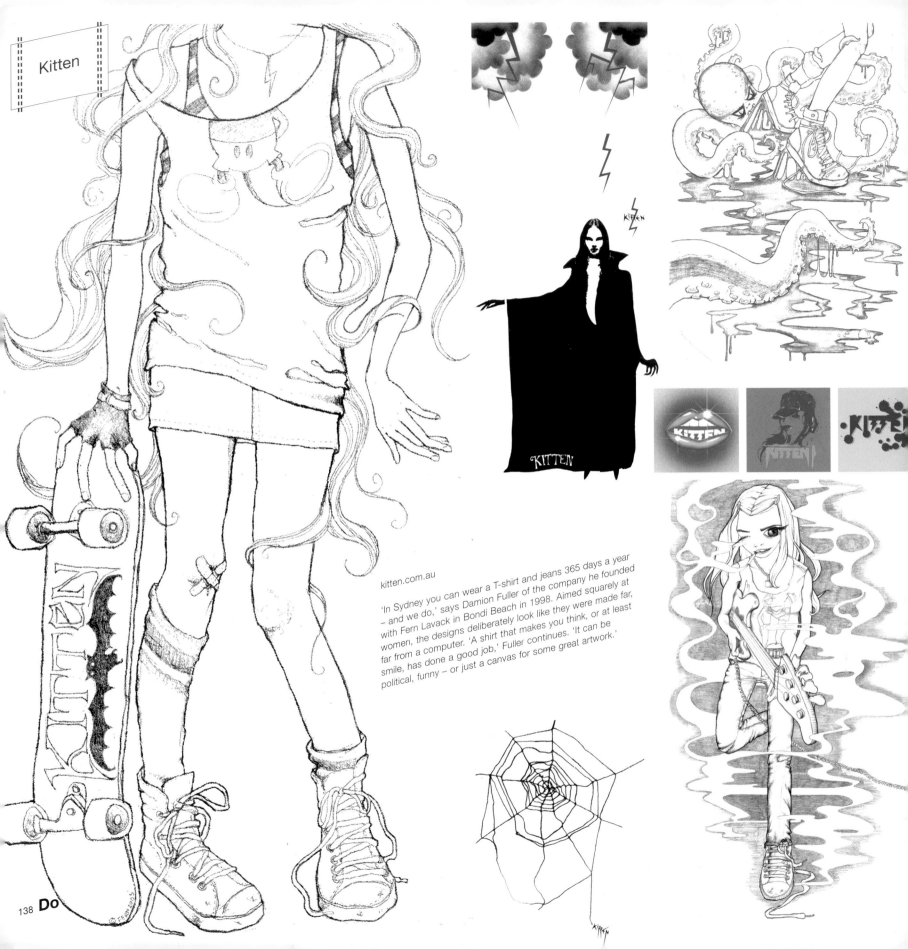

kitten.com.au

'In Sydney you can wear a T-shirt and jeans 365 days a year – and we do,' says Damion Fuller of the company he founded with Fern Lavack in Bondi Beach in 1998. Aimed squarely at women, the designs deliberately look like they were made far, far from a computer. 'A shirt that makes you think, or at least smile, has done a good job,' Fuller continues. 'It can be political, funny – or just a canvas for some great artwork.'

Somebody In Compton Loves Me!

FRESNO
IT REALLY
DOES SUCK HERE

PUG LIFE

MY BEST FRIEND IS BLACK

I Just Want To Be Loved

fanclubmember.com

Some of Globitron Fan Club's shirts are downright silly, but the guys behind the California-based line aren't ashamed. The graphics are certainly eye-catching, often slightly edgy or provocative, and as a result popular with celebrities looking to get featured in pop culture magazines (think of the picture caption possibilities).

DON'T MESS WITH THE WEST

I Wanna Rock With You

STREAK OUT!
1977 Streaking Champion
CEDAR RAPIDS, IA

The Best Things in Life Are Free

CPR DATING SERVICE
RESURRECTING YOUR SOCIAL LIFE
SINCE 1993

lifetimecollective.com

Reid Stewart and Trevor Fleming, based in Vancouver, Canada, started work on their line in 2002. Collaborating with a disparate group of friends who themselves work in a variety of media, they deliberately avoid having one unifying aesthetic. 'It's very broad,' says Stewart. 'All the artists we work with have such different styles and these translate into very different and unique shirt graphics.' Designs by: top–bottom, l–r: Ryan Wallace, Mike Carter, Simon Redekop, Ben Tour, Mike Swaney, Ephraim Chui, Ben Tour, Carl White (2), Jason Floyd, Mike Carter, Ephraim Chui

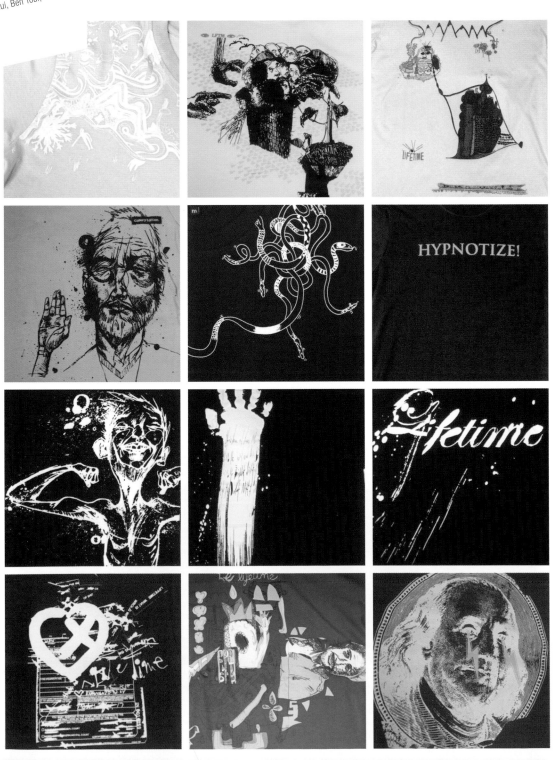

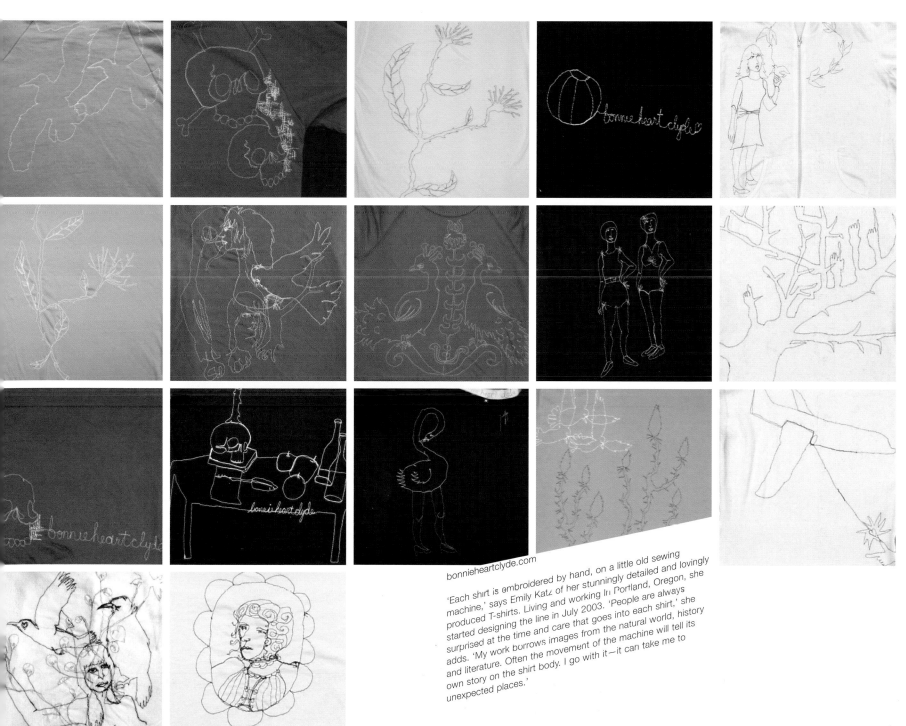

bonnieheartclyde.com

'Each shirt is embroidered by hand, on a little old sewing machine,' says Emily Katz of her stunningly detailed and lovingly produced T-shirts. Living and working in Portland, Oregon, she started designing the line in July 2003. 'People are always surprised at the time and care that goes into each shirt,' she adds. 'My work borrows images from the natural world, history and literature. Often the movement of the machine will tell its own story on the shirt body. I go with it—it can take me to unexpected places.'

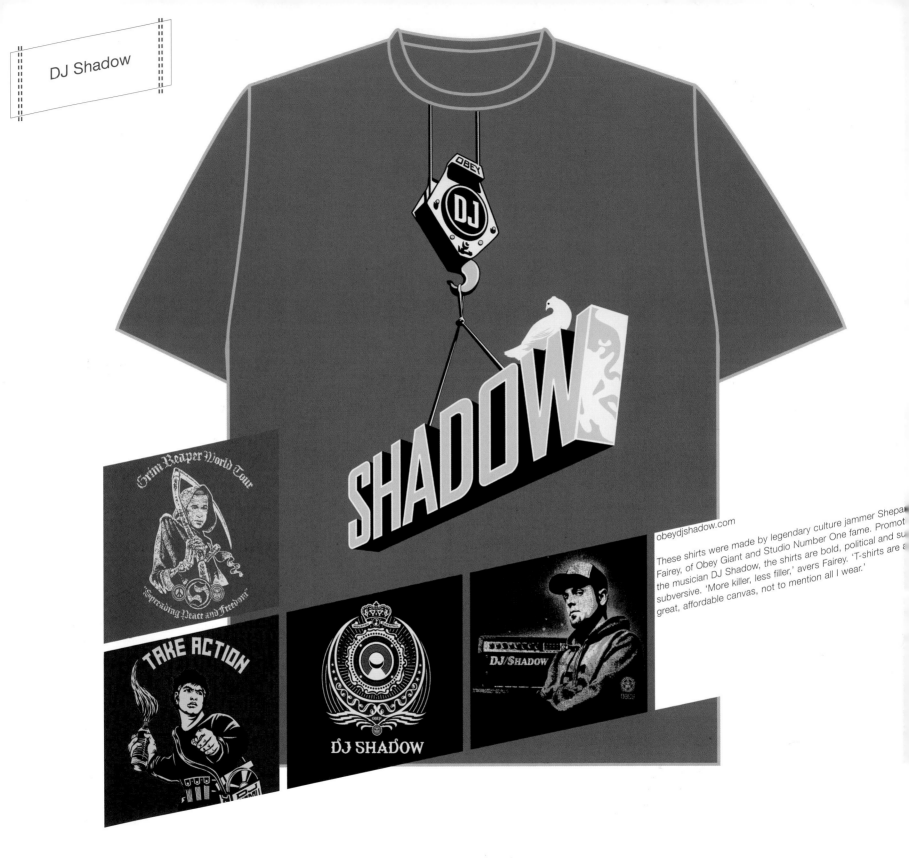

DJ Shadow

obeydjshadow.com

These shirts were made by legendary culture jammer Shepa[rd]
Fairey, of Obey Giant and Studio Number One fame. Promot[ing]
the musician DJ Shadow, the shirts are bold, political and su[b]
subversive. 'T-shirts are a
great, affordable canvas, not to mention all I wear.' avers Fairey. 'More killer, less filler,'

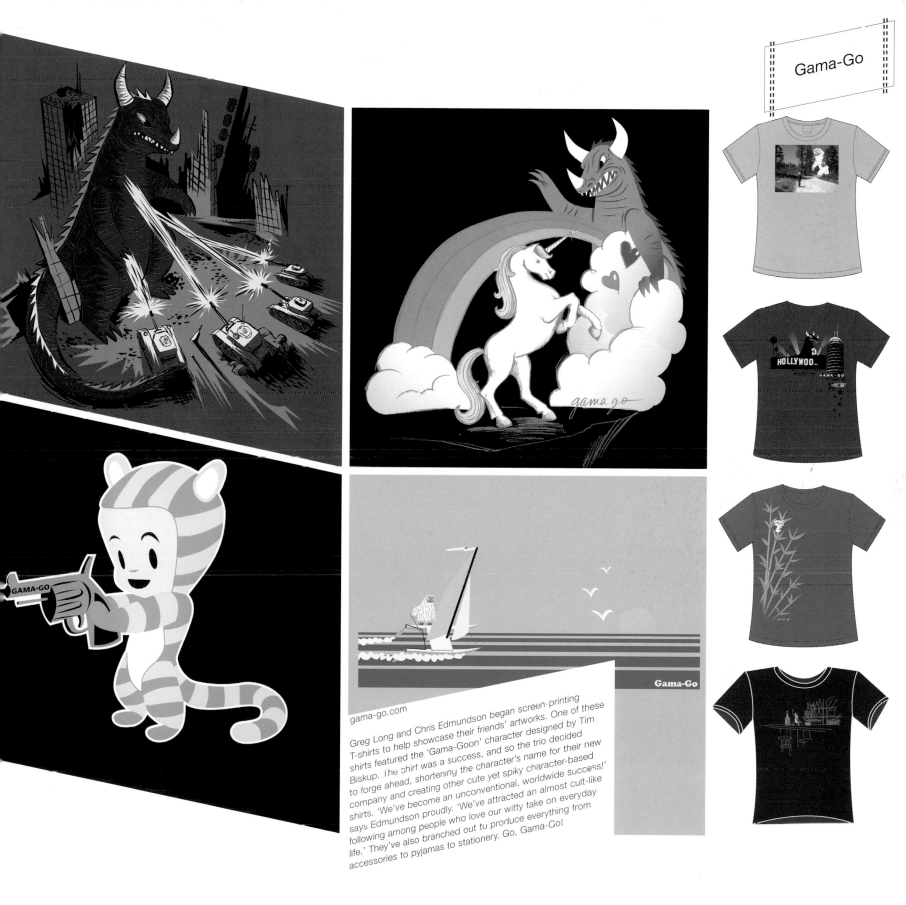

gama-go.com

Greg Long and Chris Edmundson began screen-printing T-shirts to help showcase their friends' artworks. One of these shirts featured the 'Gama-Goon' character designed by Tim Biskup. The shirt was a success, and so the trio decided to forge ahead, shortening the character's name for their new company and creating other cute yet spiky character-based shirts. 'We've become an unconventional, worldwide success!' says Edmundson proudly. 'We've attracted an almost cult-like following among people who love our witty take on everyday life.' They've also branched out to produce everything from accessories to pyjamas to stationery. Go, Gama-Go!

Acknowledgements

As always, numerous people have lent their eyes, ears, brains and unwavering support to this project.

Thanks to Laurence King and Jo Lightfoot at LKP; Catherine Hall for editing and Andy Prince for coordinating. Also to Tomi and Agathe at FL@33 for their careful eyes and beautiful design.

These people are all ace: Jon Barrett, Roanne Bell, Lloyd Blander, Leigh Ann Boutwell, Mara Carlyle, Alex Clarke, Kate Clarke, Molly Clarke, Peter Clarke, Bob Clouse, Annie Gallimore, Dom Hall, Ben Hardiman, Tessa Ingham, Will Ingham, Will Irvine, Julia Kelly, Aaron Krach, Jennifer Leader, Amber Mace, Peter Mace, Laura Marrison, Alison Prato, Vince Prato, Jennifer Pucci, April Pyle, Barbara Reyes, Jane Risien, Derek Roche, Dan Rollman, Louisa St Pierre, Shelly Surdoval, David Walters, Liz West.

And, of course, my mum and dad.